IMAGES
of America

LUDINGTON

1830–1930

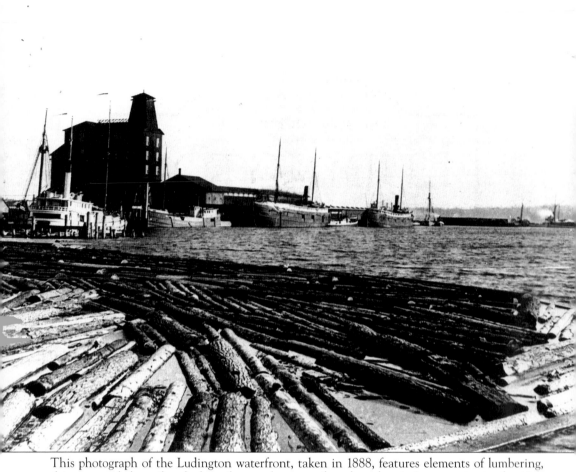

This photograph of the Ludington waterfront, taken in 1888, features elements of lumbering, shipping, and the railroad, three factors that contributed to the city's prosperity in the 19th century. (Courtesy of the Mason County District Library.)

IMAGES
of America

LUDINGTON

1830–1930

James L. Cabot

ARCADIA

Published by Arcadia Publishing
Charleston SC, Chicago IL, Portsmouth NH, San Francisco CA

Printed in Great Britain

Library of Congress Catalog Card Number: 2005928474

For all general information contact Arcadia Publishing at:
Telephone 843-853-2070
Fax 843-853-0044
E-mail sales@arcadiapublishing.com
For customer service and orders:
Toll-Free 1-888-313-2665

Visit us on the Internet at http://www.arcadiapublishing.com

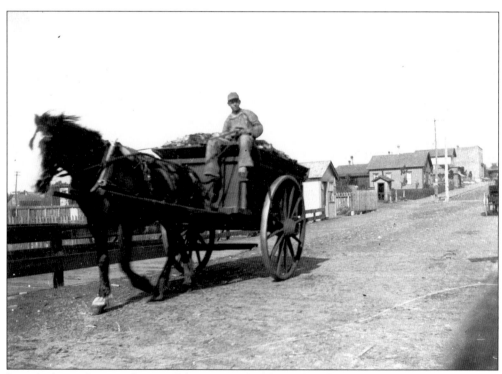

In early days, schooners from Buffalo, New York, delivered coal to Ludington a few times a year. As the years passed, this trade was taken over by steamers. In this c. 1900 image, a coal delivery wagon crosses the Washington Avenue Bridge bound for a retail customer in the Fourth Ward. (Courtesy of Jack Holzbach.)

CONTENTS

ACKNOWLEDGMENTS

I dedicate this book to my grandparents, Frank Cabot (1903–1978) and Bernice Cabot (1906–2000), who instilled in me at an early age an interest in the history of Ludington, and always encouraged my efforts to record and preserve our local history.

Publishing this book has been made possible by the support of individuals and institutions that have generously shared their photographs and historical materials for my local history archive over a period of more than 25 years. It has enabled me to assemble a photographic profile of the community, one which particularly covers the period of the lumber era. Many have also helped by providing comments, photograph identifications, or other information.

Such persons, businesses, and institutions that have made publishing this book possible include Ed and Patt Briscoe, the late Frank and Bernice Cabot, Judy Caldwell, the late Theodore H. Caldwell Jr., the late Percy Campeau, Art Chavez, Hazel Christie, Jerry and Sally Cole, Alan and Annette Doerr, the late George Egbert, Jim Fay, the late Charles Gebhardt, James Goulet (Ludington Photo Center), Grace Episcopal Church, the late Jane Gray, Julie Rye Himebaugh, Jack Holzbach, Walter Hornberger, Marilyn Johnson, the late Valdemar V. Johnson, the late Bruce Kinney, Sherry Koob, the late Doris Fester Lessard, the late LaVern F. Lorentz, *Ludington Daily News*, Ludington Mural Society, Gail Lyons, Manistee County Historical Museum, Janice Marker, Mason County District Library, LeRoy H. Meyer, Pat Miedema, Paul S. Peterson, Laurel Prafke, Brenda Rohde, Tom Sellers, the late Ray Short, Christa Shoup, Fred and Pat Slimmen, Jill Spinelli, June Swanson, and Margaret Utley.

And a sincere thank you to Maura Brown and Anna Wilson, my editors at Arcadia, for their generous help throughout the process of making this book a reality.

INTRODUCTION

This photographic record of Ludington covers the period of 1830 to 1930. Located at the mouth of the Pere Marquette River in the heart of the richest white pine timber region of Michigan, the city owes its existence to the lumbering industry. Lumbermen in the 1830s were looking for new sources of timber as Eastern woodlands were depleted. Charles Mears scouted out possible mill sites along the Lake Michigan shoreline in 1838, traveling as far north as the present site of Manistee in a small boat. George Farnsworth conducted a similar investigation in 1844. Also in 1844, Lt. John W. Gunnison conducted an official survey of the shoreline in this region.

In 1845, Burr Caswell came to Ludington from Illinois to engage in fishing and trapping. He brought his family in July 1847, marking the start of European-American settlement in the Ludington area. In 1849, Caswell built the first frame house in the county on his farm; long neglected, it was restored by the Mason County Historical Society between 1965 and 1976.

The opening of the Illinois and Michigan Canal in 1848, combined with the general growth and development of what was then considered the West, proved a strong impetus for the lumbering industry. In 1849, the firm of Baird and Bean built a sawmill at the north end of Pere Marquette Lake. Hiram Baird was the local member. George Farnsworth acquired Baird's interest in 1851, and the mill passed into the hands of George W. Ford in 1854. Named in honor of Stevens T. Mason, the state's first governor, Mason County was organized by an act of legislature in 1855.

In the meantime, Charles Mears built sawmills at Little Sauble (his spelling) in 1851 and Big Sauble in 1854. The two settlements were renamed Lincoln and Hamlin in 1861, with the county seat moved to Lincoln from the Caswell house. James Ludington acquired the mill at Pere Marquette (as the place was then known) in 1859, and a spirited rivalry grew between Lincoln and Pere Marquette, which was platted in 1867 as Ludington. The city of Ludington was incorporated by the legislature in 1873 and Charles E. Resseguie was elected mayor; in the same year, the county seat was moved to Ludington. By that time, the number of sawmills at Ludington had grown from one to seven.

It is important to acknowledge that the world in which the pioneers lived was far different from our own. Life was tough—crude, even—with few of the social safeguards we enjoy today. That the pioneers overcame numerous obstacles to build a decent place to live and work on the lumbering frontier bespeaks their vision and tenacity.

During the period between 1830 and 1930, Ludington was 156 miles from Chicago by steamboat and 225 miles from Detroit by railway. Lumbering was the city's main focus. As the mills slipped away, civic-minded residents promoted manufacturing and tourism as

replacements for the lumber industry. By 1930, Ludington was well on its way to becoming the city it is today.

Thousands of photographs illustrate and illuminate Ludington's story. With such visual riches, to pick less than 240 requires a careful selection process. Some of the chosen photographs recall historic moments and specific subjects; other images are unique to the community and were chosen because they document and preserve our history for generations to come.

One

A SITE FOR A CITY

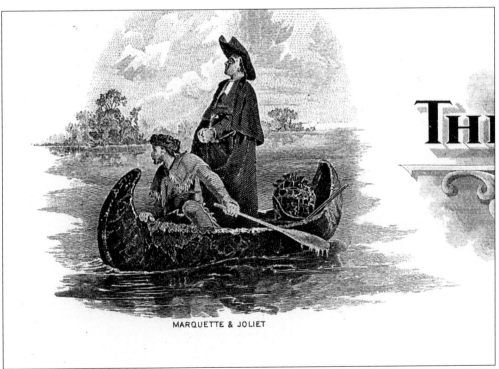

MARQUETTE & JOLIET

Father Jacques Marquette and Louis Jolliet are pictured on their voyage of exploration of 1673, in which they traveled down the Mississippi as far as Arkansas. On a later visit to the Illinois country, Marquette took ill, and while being transported to the mission at St. Ignace he died at what is now Ludington on May 18, 1675. Initially buried in Ludington, his remains were reinterred at St. Ignace in 1677. (Author's collection.)

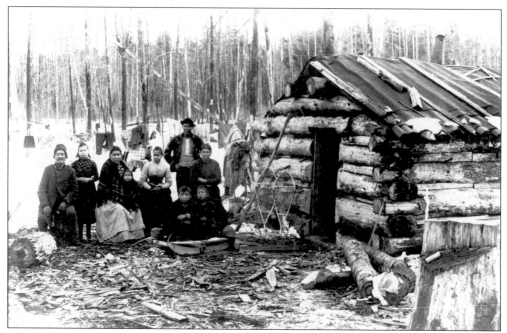

The local Ottawa Indians preserved, in their tribal lore, the memory of their contact with the kindly missionary-explorer. They pointed out Marquette's original burial place to white settlers. This is an image of an Ottawa family at their modest house in the 1880s. (Courtesy of Ed Briscoe.)

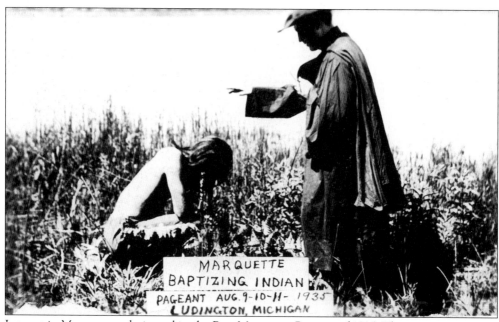

Interest in Marquette culminated in the Pere Marquette Pageant of 1935. The script was written by Robert Nelson Spencer, the Episcopal bishop of West Missouri. Local attorney Eugene Christman is pictured portraying Marquette baptizing an Ottawa Indian. A wooden cross was erected at Marquette's original burial site in 1938. Blown down by a storm in 1952, it was replaced by a metal cross completed in 1956. (Author's collection, gift of Jerry Cole.)

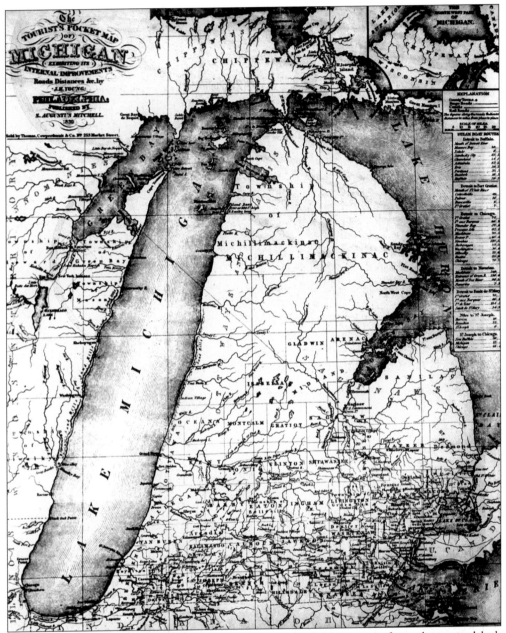

Published in 1839 by S. Augustus Mitchell of Philadelphia, this map reflects the general lack of knowledge concerning northern and western Lower Michigan at the time. To remedy this situation, lumbermen such as Charles Mears in 1838 and George Farnsworth in 1844 explored the Lake Michigan shoreline, and Lieutenant John W. Gunnison conducted a coastal survey of the same region in 1844. (Author's collection, gift of James Goulet.)

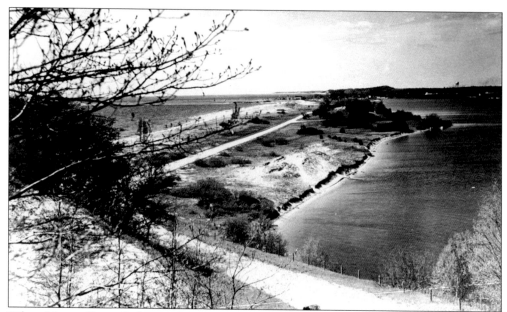

When Mason County's first settler, Burr Caswell, arrived in 1845, the natural outlet of Pere Marquette Lake was located at the indentation on the lake's southwestern shore (pictured here in 1943). In 1849, the firm of Baird and Bean built a sawmill at the north end of the lake. Because of the shallowness of the channel, lumber had to be moved by lighter to schooners waiting offshore. The mill was acquired by Farnsworth and Bean in 1851. (Author's collection, gift of the late Theodore H. Caldwell Jr.)

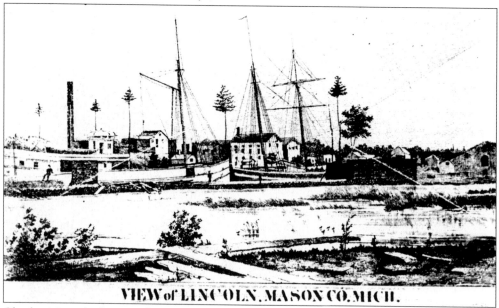

Charles Mears built sawmills at Little Sauble (his spelling) in 1851 and Big Sauble in 1854. The towns were renamed Lincoln and Hamlin in 1861 in honor of the successful Republican Presidential ticket, with the county seat moved to Lincoln from the Burr Caswell house. This engraving from Mears' letterhead depicts the village of Lincoln in its prosperous days as the county seat. (Courtesy of the late Charles Gebhardt.)

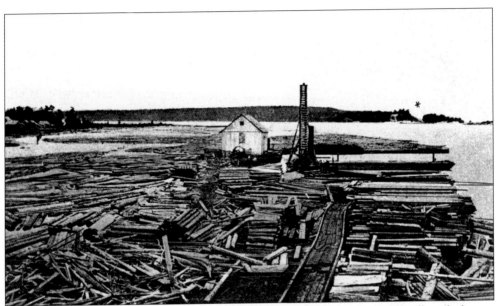

In this 1869 view, Pere Marquette Lake is seen looking south from the pioneer mill, with the site of the original channel marked with a star. At left is the site of today's car ferry dock. Around the mill grew the village of Pere Marquette. George W. Ford acquired the mill in 1854 and entered into a loan agreement with the Chicago lumber firm of Loomis and Ludington. (Courtesy of the late Doris Foster Lessard.)

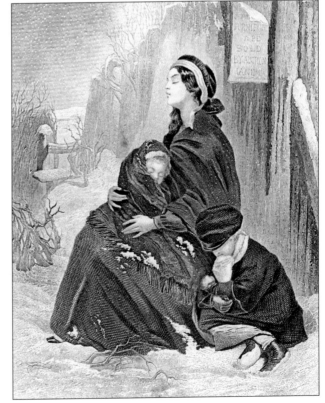

The financial panic of 1857 caused the collapse of the lumber market. Ford struggled to operate his mill, borrowing heavily from Loomis and Ludington as poverty and hunger stalked the land. This engraving, "In the Bitter Cold," appeared in *Peterson's Magazine* in January 1859, the same month Loomis and Ludington acquired Ford's mill by action of chancery court to satisfy debts totaling $69,849.71. (Author's collection.)

13

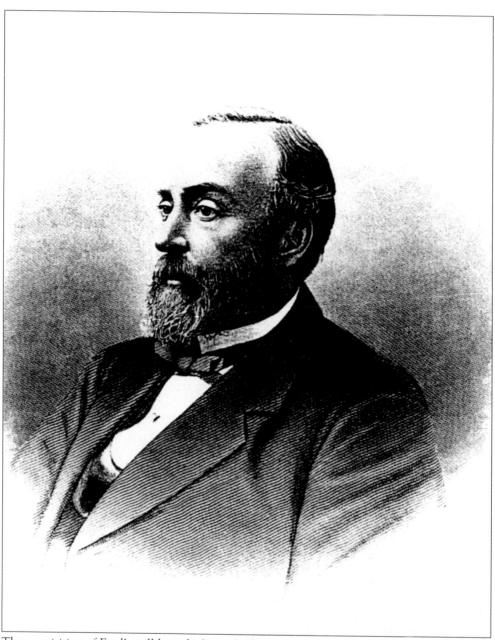

The acquisition of Ford's mill brought James Ludington (1827–1891) of Milwaukee, Wisconsin, into the Michigan lumbering business. (From May 1859 to July 1862 the mill was leased by Mears, who cut a new harbor channel at the present site in August 1860.) Ludington secured a post office named after him in 1864; in 1867 the village was platted and the area's first newspaper, the *Mason County Record*, was founded with his backing. (Author's collection.)

Steamship service was inaugurated between Milwaukee, Ludington, and Manistee in July 1867 by Michael Engelmann (1832–1888), a Manistee lumberman and vessel owner. The Engelmann Line maintained the route until its sale to the Northwestern Transportation Company in 1875; this concern withdrew from the route in 1880. (Courtesy of the late Doris Foster Lessard.)

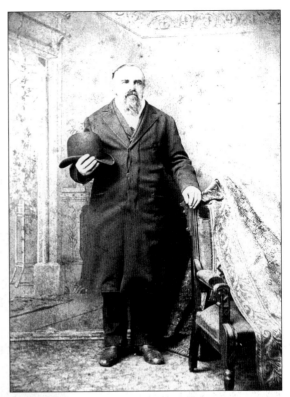

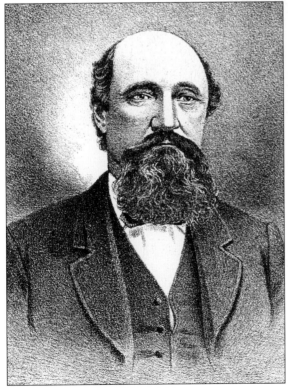

The village's first harbor tug, the *Cyclone*, was placed in service in 1867 by Captain Robert Caswell (1834–1889). He formed a partnership with Captain Amos Breining in 1871, admitting James Foley as a partner in 1877, adding the tugs *B. W. Aldrich* and *Sport* to the fleet in the process. Caswell was mayor of Ludington in 1885 and 1886. He was the father of Frances Caswell Hanna, the historian. (Author's collection.)

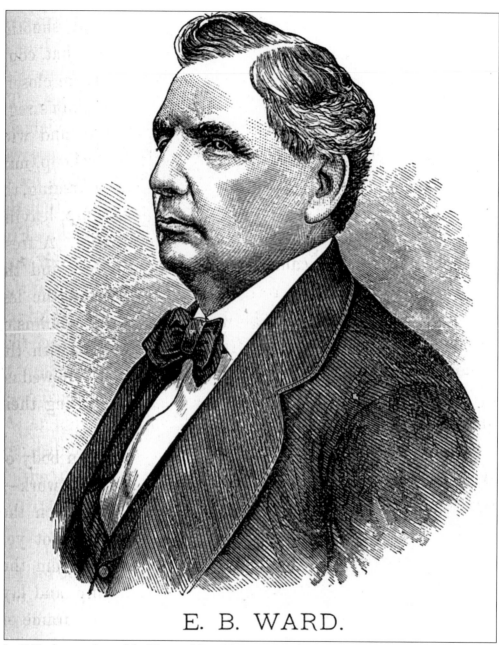

E. B. WARD.

In 1868, the president of the Flint and Pere Marquette Railway, Eber B. Ward (1811–1875) opened negotiations for the acquisition of terminal property with frontage on Pere Marquette Lake. Ward was then the richest man in Michigan; besides the railway he had interests in mining, steel mills, timber land, and vessel property. He had 70,000 acres of timber accessible to the Pere Marquette River and was not a man to be trifled with. Unfortunately, James Ludington attempted to spin out the talks. Although he favored the completion of the railway, he knew Ward had plans to build mills, and Ludington fought this because it would make Ward too big. He refused to sell Ward a mill site at any price, as he thought he could squeeze Ward into selling some of his timber land at a bargain. Ward did not sell. (Courtesy of the Mason County District Library.)

Early in 1869, Ward heard that Ludington had cut pine from portions of his 70,000 acres. He said nothing until Ludington went to Detroit on business, then had him arrested on a timber theft and trespassing charge and lodged in the Wayne County jail. Ward secured a court judgment of $650,000 against Ludington, who thereupon suffered a stroke. His successor in business, the Pere Marquette Lumber Company, reached an amicable agreement with Ward in August 1869. (Courtesy of Ed Briscoe.)

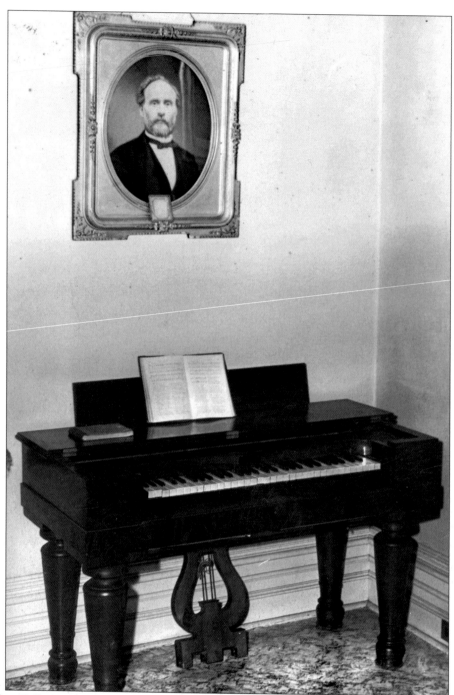

Luther H. Foster (1827–1876), a lumberman who was kin of Queen Victoria, settled here in 1866 as James Ludington's resident manager. Upon Ludington's fall in 1869, Foster was instrumental in organizing the Pere Marquette Lumber Company. He was secretary and manager of this company and a member of the firm of Foster and Stanchfield. Here, his portrait and his seraphine, a kind of melodeon he brought here from Maine, are seen during the Mason County Centennial in 1955. (Russ Miller photograph; courtesy of the late Doris Foster Lessard.)

Two

THE MILLS

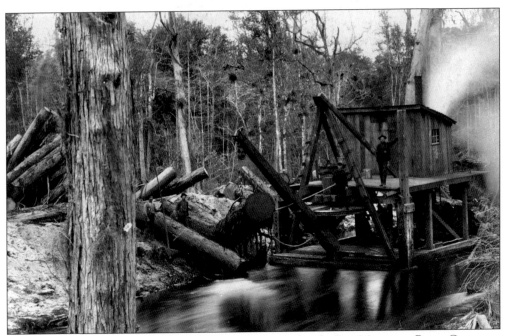

Here, a steam lifter for cleaning log jams is seen in action on the Pere Marquette Boom Company, organized in 1872, but the maintenance of the river as a waterway for lumbering was the province of the Pere Marquette River Improvement Company, organized in 1877, and the Little South Branch Pere Marquette River Improvement Company, established in 1881. (Courtesy of Ed Briscoe.)

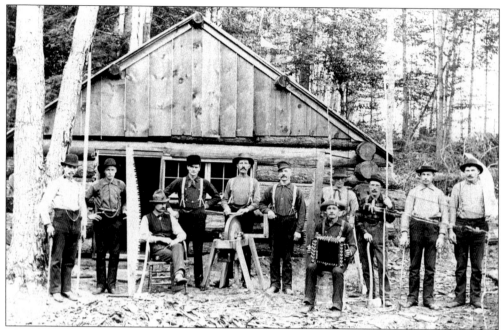

This is the lumber camp office of Foster and Stanchfield, c. 1875. The members of the firm were Luther H. Foster and Edward A. Foster and their brother-in-law, Oliver O. Stanchfield. Stanchfield is seated third from left in this photograph. His nephew, Edward F. Stanchfield, the firm's timber cruiser, is sixth from left. (Courtesy of the late Doris Foster Lessard.)

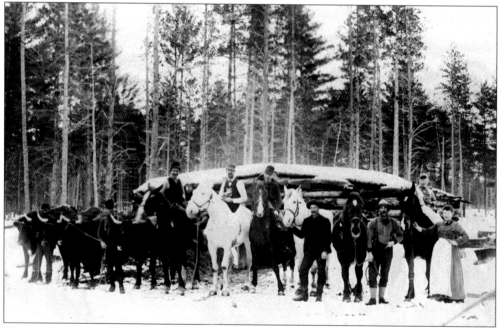

Here we see a typical lumber camp group in 1888, assembled in front of a hay barn. The camp foreman (on white horse) and the woman on horseback at right are holding cats, which were evidently kept to guard against rodents. By this date, it was not unusual to see female cooks in camp. (Courtesy of Ed Briscoe.)

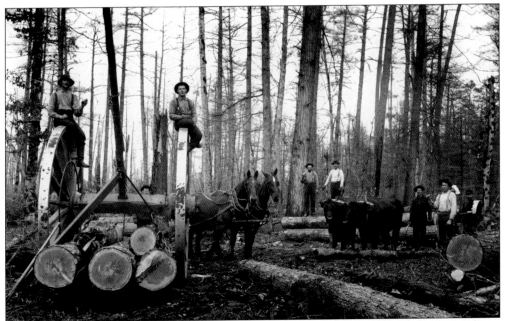

Seen here with one of T. R. Lyon's logging crews, these huge wheels enabled loggers to haul logs on the dry, relatively flat forest floor in summer. The best-known manufacturer of logging wheels, Silas C. Overpack of Manistee, "received first premium and medal" at the Chicago World's Fair in 1893. (Courtesy of Ed Briscoe.)

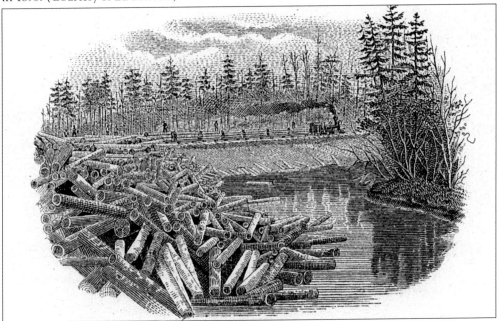

Logs were banked, or piled, on riverside inclines called rollways until spring, when they were then floated downriver. At the mouth of the river they were run through the sorting gap, where the logs were separated on the basis of owners' marks, gathered in floating booms, and towed by tugs to the mills. The engraving is from a Cartier billhead. Note the logging train with men stationed at intervals on the log cars. (Author's collection, gift of the late Doris Foster Lessard.)

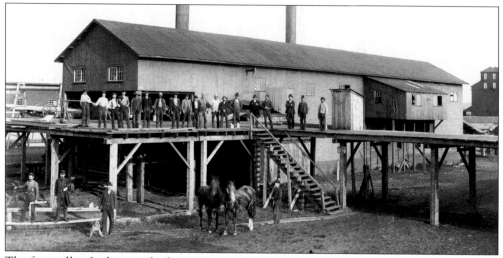

The first mill at Ludington, built in 1849, passed into the hands of the Pere Marquette Lumber Company in 1869. When it burned in March 1874, it was replaced with a bigger mill, seen in this 1888 photograph. Visible in the background at left is the company's salt manufacturing plant (the city's first), completed in 1885. Both plants were closed down in September 1897. (Author's collection, gift of Ed Briscoe.)

Headquarters for Lumbermen's

P. M. DANAHER. J. E. DANAHER.

DANAHER & MELENDY CO.,

Manufacturers of

Circular Sawed Lumber!

And Dealers in

GENERAL MERCHANDISE,

Mill, Store and Office, {
FOURTH WARD.

Ludington, Mich.

BOOT-PACKS, *SHOE-PACKS and WOOL BOOTS at LARSEN BROS., Manistee.*

The town's second mill was built in 1869 to 1870 by the firm of Patrick M. Danaher and David A. Melendy, in which James Ludington was a silent partner. The firm was incorporated in 1876. This advertisement appeared in the 1883 city directory. The company purchased a second mill in 1895 at Dollarville in Luce County. The mill at Ludington was closed down in September 1902. (Courtesy of Mason County District Library.)

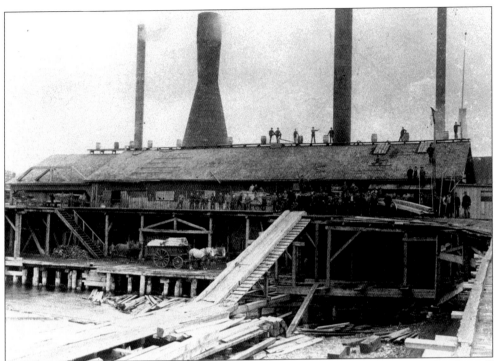

Eber B. Ward built his North Mill in 1870. As is the case of other Fourth Ward mills, the mill and dock were built on wooden piles offshore with the intervening space backfilled with slabs, edgings, sawdust, and fill soil. After Ward's death in 1875, the mill passed into the hands of T. R. Lyon in 1878, and J. S. Stearns in 1898. Extensively rebuilt, it was Ludington's last mill, surviving until 1917. (Courtesy of Ed Briscoe.)

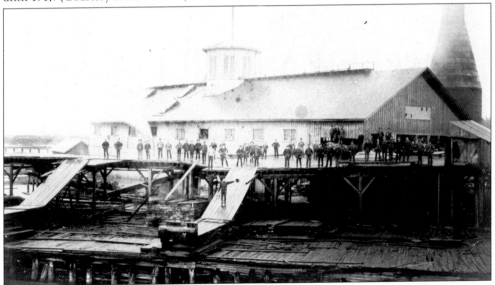

Built in 1872, E. B. Ward's South Mill was said to be the finest in America at the time. It passed into the hands of T. R. Lyon in 1878 and was closed down in 1893 on account of the business depression that commenced that year. The mill was about to be dismantled when it burned on the night of September 20, 1895. (Courtesy of Ed Briscoe.)

Begun in 1872 by Vahue, Hustis, and Company, this mill was purchased and completed by Foster and Stanchfield. After being briefly operated by Gibbs and Filer, it was acquired by Cartier and Filer in 1878. Purchased by Butters and Peters in 1882, it was rebuilt after a fire on May 8, 1892. A second fire wiped out the mill and salt manufacturing plant on August 24, 1909. (Courtesy of Ed Briscoe.)

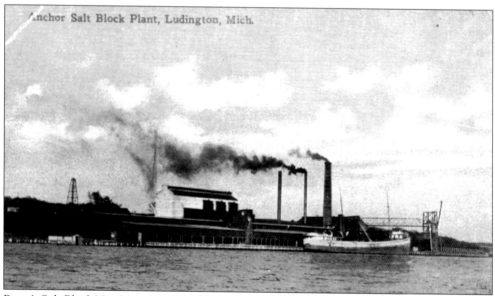

Percy's Salt Block No. 2 was built in 1893 on the site of the burned Pardee, Cook, and Company mill by Thomas Percy, who also leased T. R. Lyon's salt plant. In November 1898, Percy sold his Salt Block No. 2 to the Anchor Salt Company, which became the Morton Salt Company in 1912. The plant closed in 1932; on its site the present Dow Chemical plant was built in 1942–1943. (Author's collection.)

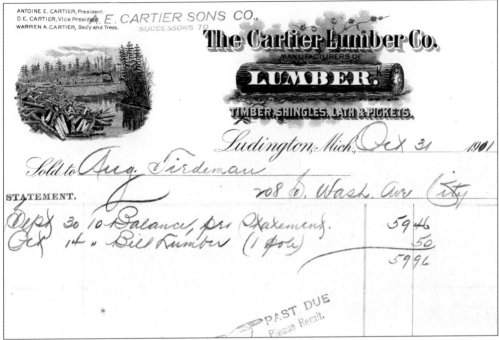

The Cartier mill was built in 1882 at the foot of James Street by William Allen and George Goodsell. Antoine E. Cartier purchased their shares in 1883 and 1884, and organized the Cartier Lumber Company in 1892. The mill was rebuilt after a fire in July 1893. After Cartier's death, the concern became the A. E. Cartier Sons Company, as shown on this 1911 billhead. Again rebuilt in 1912, the mill closed down in 1914. (Author's collection, gift of the late Doris Foster Lessard.)

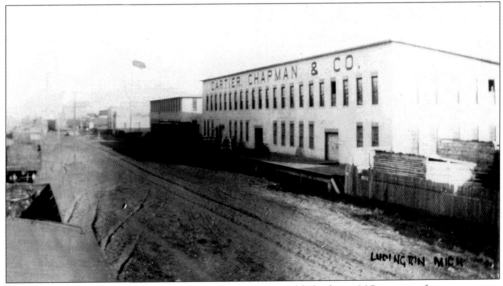

The firm of Cartier, Chapman, and Company was established in 1905 to manufacture wagons and sleighs. This view looks east on Lake Street, c. 1909. The plant later produced wood lawn and porch furniture until 1919. It was occupied by the Monroe Body Company, makers of steel automobile bodies, from 1920 until it burned on November 15, 1922. The Thompson Cabinet Company was built on the site in 1925. (Courtesy of Jerry Cole.)

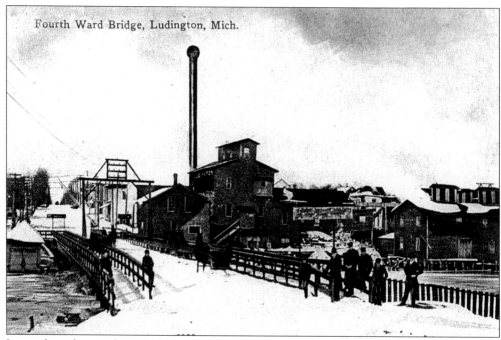

Fourth Ward Bridge, Ludington, Mich.

Located at the north end of the Washington Avenue Bridge, the Ludington Woodenware Company was established in 1889 by Henry B. Smith to manufacture wood products including bowls, clothespins, butter molds, handles, and wire-end dishes. Known familiarly as the "Pin Mill," the plant was closed down in 1914–1915 when Smith moved the operation to Wilmington, Vermont. (Author's collection.)

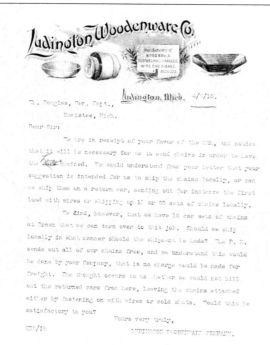

This letter was written April 9, 1910, by Henry B. Smith, manager of the Ludington Woodenware Company, to William Douglas, general superintendent of the Manistee and North-Eastern Railroad. Note the engraving illustrating some of the company's products. Smith moved the plant to Vermont less than five years later. He died in 1918. (Author's collection, gift of Jim Fay.)

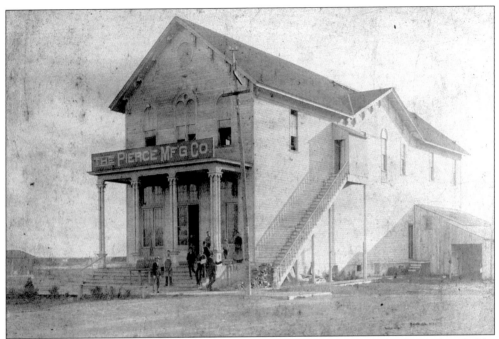

Here the Pierce Manufacturing Company plant is seen in 1891, a year after being founded by Frank B. Pierce. The plant was located in the former Pere Marquette Lumber Company store, built in 1867 as James Ludington's store. The factory produced wood-handled brooms and brushes until 1915; the building was razed in 1918. (Author's collection, gift of Jerry Cole.)

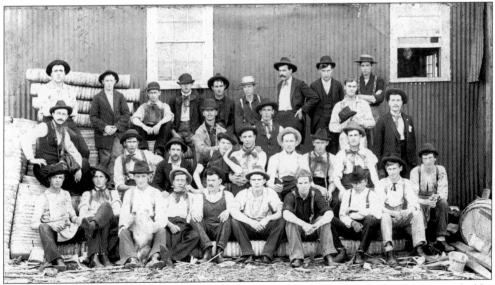

The development of the fruit-growing industry made the operation of a basket factory profitable. Its operation was seasonal and lacked a large payroll, but its existence was a boost to the morale of the community. Pictured are employees of the Ludington Basket Works, established in 1893 with W. A. Wheatley as manager. The plant burned August 30, 1897, and was rebuilt as the Phoenix Basket Works. It burned again on May 30, 1903. (Author's collection, L. F. Swarthout photograph, gift of Jack Holzbach.)

Built in 1867 at the southwest corner of Ludington Avenue and Main Street (now Gaylord), James Ludington's store passed into the hands of the Pere Marquette Lumber Company in 1869. It was, for a long time, the largest retailer in the county. This advertisement appeared in the city directory of 1883. The store moved to a new building uptown in 1888 and became independent of the lumber company in 1892. (Courtesy of Mason County District Library.)

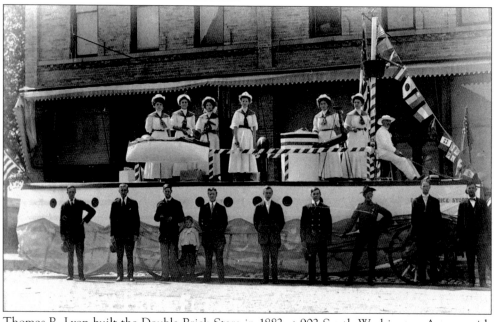

Thomas R. Lyon built the Double Brick Store in 1882 at 902 South Washington Avenue with an office at the rear overlooking the North Mill. Sold to J. S. Stearns in 1898, it was acquired by the Cartier lumber interests in July 1903. Here it is shown with a prize-winning Labor Day float while operated by the Cartier-Magmer Company. (Courtesy of Hazel Christie.)

This letter dated September 7, 1911, solicited business from August Tiedemann, local architect and builder. Absorbed by the A. E. Cartier Sons Company in 1911, the store closed in 1918. The building was occupied by Pellar Brothers with a cherry-canning plant when it was gutted by fire in 1927. (Author's collection, gift of the late Doris Foster Lessard.)

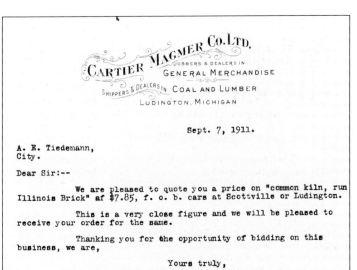

An immense volume of salt was produced by plants at Ludington between 1885 and 1932. This view is of the interior of the Buckley and Douglas plant at Manistee, but it is typical of the large salt plants of Saginaw, Bay City, Ludington, and Manistee. (Author's collection.)

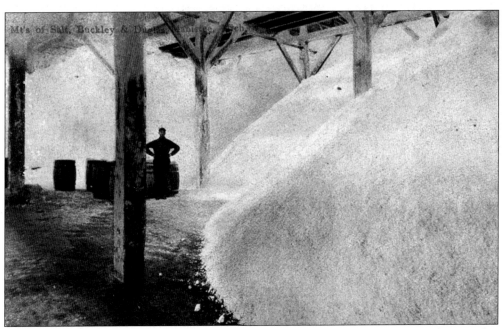

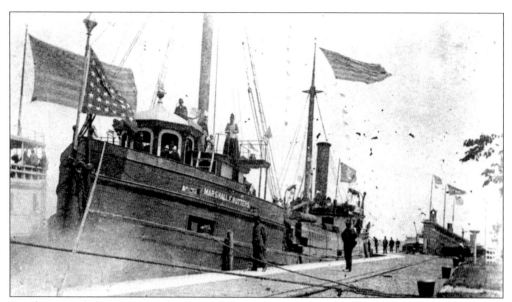

Best-known of the steamers that carried Ludington lumber to Chicago was the *Marshall F. Butters*, built in Milwaukee in 1882 for Butters, Peters, and Company. Here the *Butters* is seen at Sault Ste. Marie with the Butters family on board on July 4, 1891. Owned after 1903 by the Ludington Transportation Company, the *Butters* was lost in a storm on Lake Erie on October 20, 1916, but all hands were rescued. (Courtesy of Jack Holzbach.)

Built in 1868 at Fort Howard, Wisconsin, the schooner *George L. Wrenn* was owned for a number of years by Emery D. Weimer of Ludington. Seen here in a rare view printed from the original glass negative, the *Wrenn* is shown going into winter lay-up at the Stearns wharf, *c.* 1900. Last owned by the Scheunemann family of Thompson, Michigan, the *Wrenn* was abandoned in 1911. (Courtesy of Jack Holzbach.)

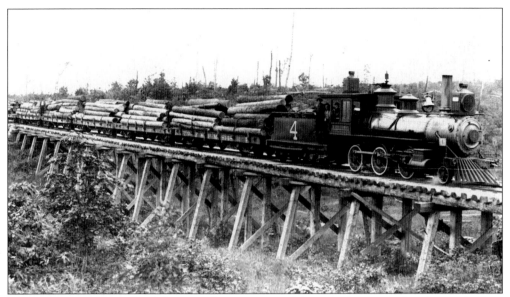

As loggers moved away from the immediate vicinity of the river, logging railroads were built to haul logs to the rollways at the river's edge. In 1880, Thomas R. Lyon built the Lake County Railroad south from Wingleton, where it connected with the Flint and Pere Marquette, and went into a rich section of pine. Lake County engine No. 4 is seen hauling a logging train on a trestle in 1888. (Courtesy of Ed Briscoe.)

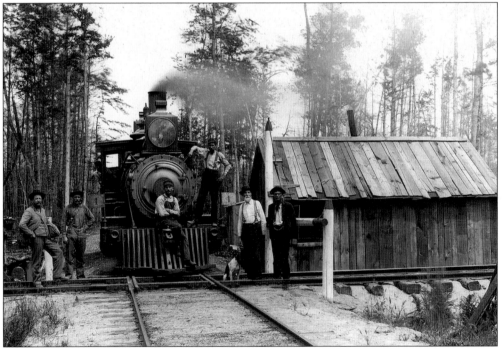

Engine No. 4 of the Lake County Railroad is seen at a track crossing in 1888. This locomotive was built in 1887 by the Brooks Locomotive Works. The Lake County Railroad was abandoned in 1893, five years before Lyon sold his remaining timber interests to his brother-in-law, J. S. Stearns. (Courtesy of Ed Briscoe.)

Begun in 1883, the Mason and Oceana Railroad hauled logs directly to the Butters and Peters mill at Buttersville. Here engine No. 2 is ready for work in 1902. This type of geared logging engine was invented by Ephraim Shay and built by the Lima Locomotive Works; engine No. 2 was built by Lima in 1884. After fire destroyed the Butters mill in 1909, the Mason and Oceana was abandoned. (Courtesy of Ed Briscoe.)

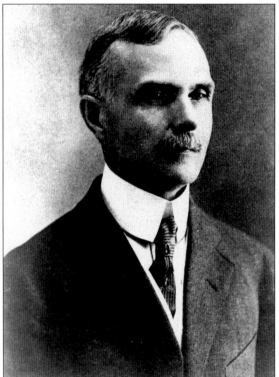

The second son of Patrick M. Danaher, the lumberman Michael B. Danaher (1855–1940), practiced law in Ludington from 1880 to 1938. A Democrat, he was mayor in 1901 and for 12 years was a member of the school board. The late Luman W. Goodenough attributed Danaher's lack of political advancement to "the misfortune of a lameness of leg and arm from infancy and a large inherited lumber fortune." (Author's collection.)

Three

THE LUMBERMEN

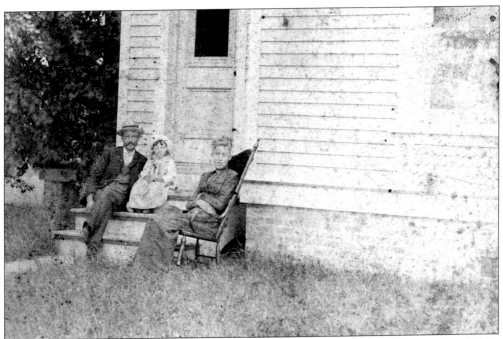

Frank B. Pierce (1850–1916) was kin to President Franklin Pierce and a brother-in-law of D. L. Filer. He was a lumber inspector in Ludington from 1874 until 1895, and was also the proprietor of the Pierce Manufacturing Company from 1890 to 1915. Here he is seen at his home at 302 North Main Street (now Gaylord) with daughter Flora and wife Carrie on June 30, 1891. (Author's collection, gift of Jerry Cole.)

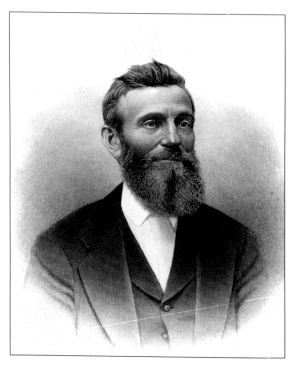

Born in Herkimer County, New York, to parents of Scottish ancestry, Delos L. Filer (1817–1879) was a lumberman at Manistee before coming to Ludington in 1869 as president of the Pere Marquette Lumber Company. He was also part-owner of the Milwaukee firm of Filer and Stowell, manufacturers of engines and mill machinery. Filer was mayor of Ludington in 1876. His death from cancer was considered a public calamity. (Author's collection.)

John Mason Loomis (1825–1900) organized the firm of Loomis and Ludington with James Ludington in 1849. He was colonel of the 26th Illinois Infantry in 1861 through 1864 and succeeded Filer as president of the Pere Marquette Lumber Company in 1879. Where Filer had been approachable and generous, Loomis was aloof and tightfisted. When Loomis died, Charles T. Sawyer of the *Ludington Record* published a bitter denunciation of the dead lumberman. (Courtesy of Mason County District Library.)

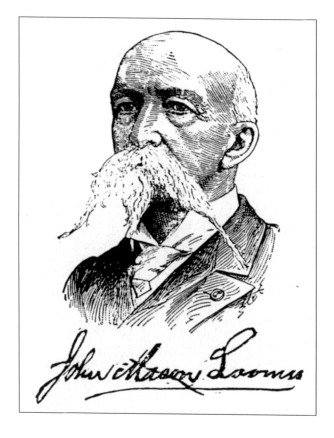

An Irish immigrant, Patrick M. Danaher (1821–1886) engaged in lumbering and railroad construction before coming to Ludington in 1863 to engage in logging. In 1869, he formed a partnership with David A. Melendy and built a sawmill. Danaher was mayor of Ludington in 1874 and 1875. His eldest son, James E. Danaher (1851–1947) was president of the Danaher and Melendy Company from 1884 until 1902. (Author's collection.)

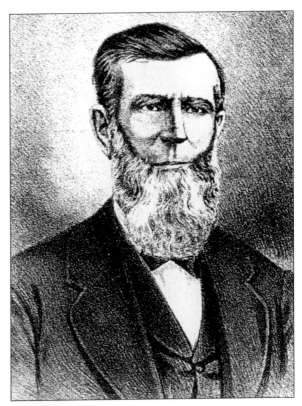

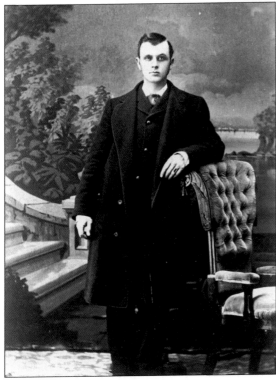

A native of Conneaut, Ohio, Thomas R. Lyon (1854–1909) came to Ludington in 1872 as a cashier in the office at the Ward mills. In 1878, he took over management of the mills from the estate of his brother-in-law, E. B. Ward. President of the First National Bank in 1892 through 1895, he left for Chicago in 1894. Lyon sold his Ludington holdings to another brother-in-law, J. S. Stearns, in 1898. (Courtesy of the late Doris Foster Lessard.)

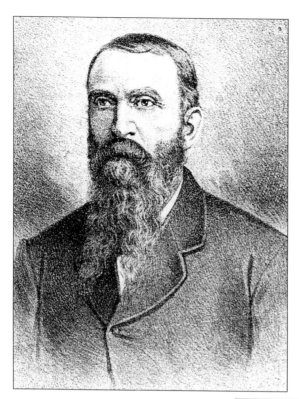

An Ohio state senator in 1861–1862, George W. Roby (1823–1900) practiced medicine until he came to Ludington in 1871. He organized George W. Roby and Company and built a sawmill in 1872–1873. He was president of the First National Bank from 1882 to 1892. After selling his mill to Pardee, Cook, and Company in 1887, Roby moved to Detroit. He was the namesake of the freighters *George W. Roby* and *Senator*. (Author's collection.)

A native of New York state, Lewis C. Waldo came to Ludington from Milwaukee in 1873 as a bookkeeper for George W. Roby and Company. He married Roby's daughter, Minnie, in 1876. Waldo was city treasurer in 1878 and 1879 and secretary of the George W. Roby Lumber Company in 1882 through 1887. Moving to Detroit in 1890, he was manager of the Roby Transportation Company and namesake of the freighter *L. C. Waldo*. (Courtesy of Julie Rye Himebaugh.)

Oliver O. Stanchfield (1834–1893), seen seated at the left, practiced law in Iowa before coming to Ludington in 1873 as a member of the firm of Foster and Stanchfield. He moved to Dakota Territory in 1883. At the far right is his nephew, Edward F. Stanchfield (1847–1888), a noted timber cruiser. (Courtesy of the late Doris Foster Lessard.)

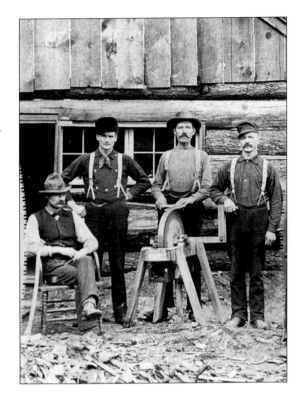

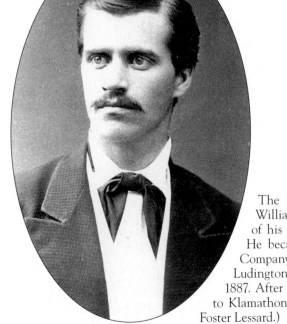

The son of John R. Cook, the lumberman William E. Cook is pictured here at the time of his graduation from Olivet College in 1874. He became manager of the Pardee, Cook, and Company mill at Hamlin in 1877 and moved to Ludington upon the purchase of the Roby mill in 1887. After this mill burned in 1891, the firm moved to Klamathon, California. (Courtesy of the late Doris Foster Lessard.)

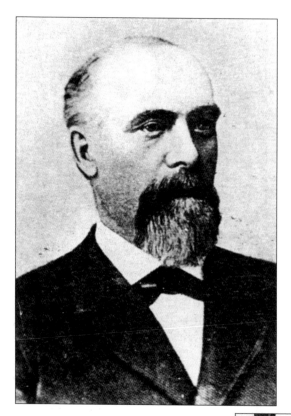

Born near Trois Rivieres, Quebec, Antoine E. Cartier (1836–1910) was kin of the explorer Jacques Cartier. After engaging in lumbering at Manistee he came to Ludington in 1877 and was a mill owner in partnership with Frank Filer from 1878 to 1882. In 1883–1884, he purchased what became the Cartier mill. Mayor of Ludington in 1880 and 1881, he donated Cartier Park to the city in 1909. (Courtesy of Manistee County Historical Museum.)

Born at Manistee, Warren A. Cartier (1866–1934) became manager of the Cartier mill upon graduating from the University of Notre Dame in 1887. At its incorporation in 1892, he was secretary and treasurer of the Cartier Lumber Company. He was mayor of Ludington in 1899 and 1903. President of Ludington State Bank after 1921, Cartier is pictured at the Rainbow Club in the 1920s. (Author's collection.)

Youngest of the six Cartier sons, Charles E. Cartier was part-owner of the Cartier-Magmer Company and later served as president of the A. E. Cartier Sons Company. He was mayor of Ludington in 1908 and 1909 and state senator at the session of 1911. He moved to Grand Rapids in 1915 and South Bend, Indiana, in 1919. At the Mason County Centennial in 1955, he was Ludington's last surviving former mill owner. (Author's collection.)

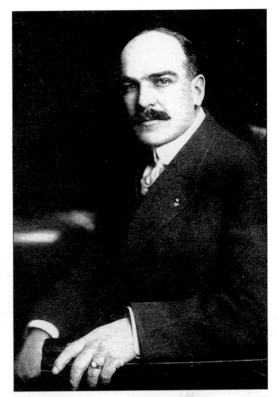

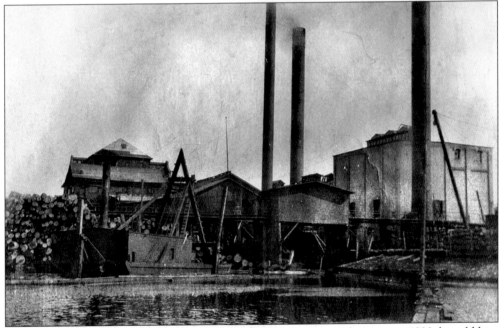

Family was important. When Thomas R. Lyon left the lumbering business in 1898, he sold his mill and salt plant to his brother-in-law, Justus S. Stearns (1845–1933). The Stearns Salt and Lumber Company was organized in 1902 by Justus, his son, Robert L. Stearns (1872–1939), and W. T. Culver (1863–1940), a long time associate. (Author's collection, gift of Sherry Koob.)

Lumbermen often had varied interests. Long active as a lumber inspector, Emery D. Weimer (1856–1911) also owned the schooners *George L. Wrenn* and *Grace G. Gribbie*. From 1909 until his death, he had extensive timber holdings in British Columbia. (Author's collection.)

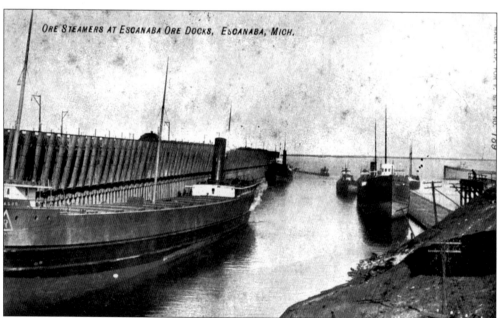

ORE STEAMERS AT ESCANABA ORE DOCKS, ESCANABA, MICH.

Several ships were named for local lumbermen. Pictured is the freighter *L. C. Waldo* at the Escanaba Ore Docks in the early 1900s. Other vessels named for Ludington lumbermen included the schooner *D. L. Filer* and the freighters *Marshall F. Butters*, *George W. Roby*, *Senator* (named also for Roby), *John B. Lyon*, and *Henry B. Smith*. (Author's collection.)

Four

THE NEW COUNTY SEAT

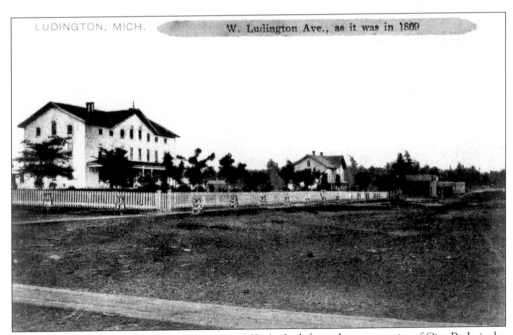

LUDINGTON, MICH. W. Ludington Ave., as it was in 1869

This is the business district of Ludington in 1869. At far left, at the present site of City Park, is the D. L. Filer residence, built in 1865–1866 as a mill boarding house. It was converted into a hotel named the Filer House in 1880 and was razed in 1895. On the next corner to the east is the Farrell House, built in 1867 by William Farrell; beyond are a few stores. (Courtesy of Janice Marker.)

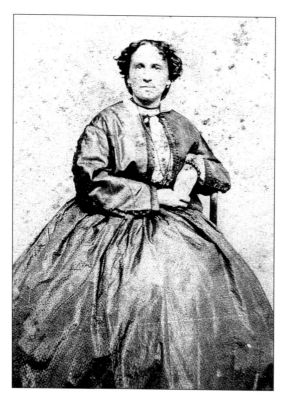

The twice-widowed sister of Luther H. Foster, Maria Hutchins (1823–1880) came to Ludington from Maine in 1868. She and her daughters, Emma Stanchfield and Charlie M. Hutchins, taught at the high school in Ludington. Maria's son, Edward F. Stanchfield, was a lumberman. (Courtesy of the late Doris Foster Lessard.)

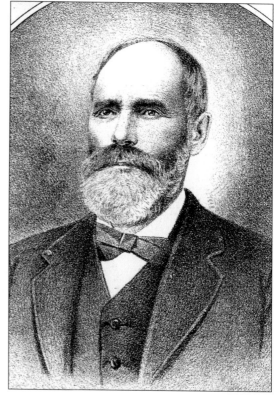

Known familiarly as "Uncle Gus Foster," Edward A. Foster (1830–1902) came to Ludington from Muskegon in 1869. A younger brother of Luther H. Foster, he was with the firm of Foster and Stanchfield from 1872 to 1876 and manufactured shingles from 1877 to 1882. After 1885 he operated a sawmill at Merrill, Wisconsin, near Wausau. His death at Wausau in 1902 was front-page news in Ludington. (Author's collection.)

William Rath (1849–1916) came to Ludington as a German immigrant in June 1870 and went to work in the mills. He later became a lumber inspector, forming the partnership of Weimer and Rath with Emery D. Weimer in 1881. He also engaged in lumbering with Warren A. Cartier under the name Rath and Cartier. Rath was collector of customs for the port after 1895 and mayor in 1910. (Author's collection.)

In 1871, Luther H. Foster's brother-in-law, Joshua Allen, and nephew, Eugene C. Allen, came to Ludington from Maine and built a handle factory. After the plant burned in June 1872, they purchased the steamboat wharf at the foot of Main Street (now Gaylord), where they were in the warehousing business until 1894. Eugene Allen (pictured here) was collector of customs for the Port of Ludington from 1881 to 1885. (Author's collection.)

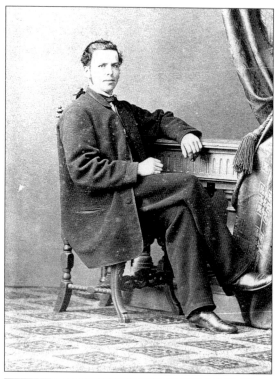

A native of Sudetenland, the German-speaking part of Bohemia, Anton Herrgesell (1820–1886) came to Ludington from Milwaukee in 1871. He built a saloon and boarding house in 1873 at 129 Second Street. This was one of the first businesses in the Fourth Ward. After Herrgesell's death, the boarding house was operated by his daughters until 1941. (Courtesy of the late Doris Foster Lessard.)

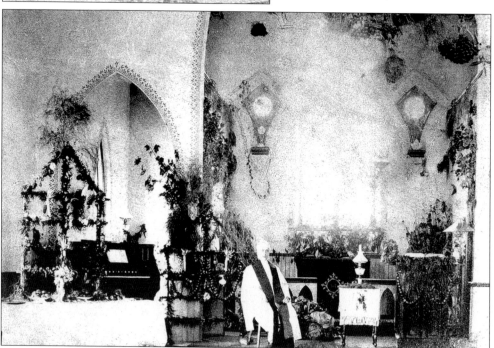

The Rev. Joseph B. Prichard (1813–1892) came to Ludington in May 1872 as the Episcopal missionary for this part of the state. Grace Church was organized in May 1873, and a building was erected in 1874. Prichard is seen in the church (decorated for harvest time) in the 1870s. (Courtesy of Grace Episcopal Church.)

Ludington was incorporated as a city by the legislature on March 22, 1873, but it was not until September 1874 that a fire department was organized. Because the first fire chief, Bennett J. Goodsell, and many members were German immigrants, the fire department was established as Germania Engine Company. Two of the original members are pictured here with their wives. From left to right they are Caroline and August Tiedemann and Katie and Charles Boerner. (Courtesy of the late Doris Foster Lessard.)

In December 1874, the Presbyterian Church of Ludington was organized by Rev. Samuel N. Hill (1815–1891), who came here from Tuscola County. In addition to his city church, Hill made trips on horseback to minister to the isolated logging and farming settlements. A church building was erected in 1876, and he served until advancing age compelled his retirement in 1888. (Courtesy of Jim Fay.)

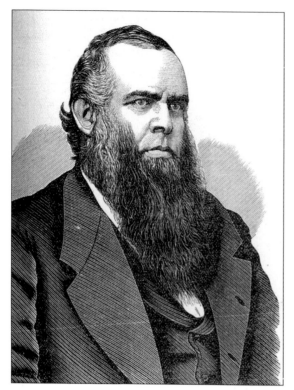

"In November of 1874," wrote Charles G. Wing in 1920, "when the F&PM railroad was nearly completed to Ludington, Governor John J. Bagley came over the line on a tour of inspection . . . [and] received the most distinguished mark of attention Ludington could show. He rode to and from his railroad car in the only covered carriage up to that time ever owned within the borders of Mason County." (Courtesy of Mason County District Library.)

The Flint and Pere Marquette Railway was completed in Ludington on December 1, 1874. Cross-lake steamship service was inaugurated between Ludington and Sheboygan, Wisconsin, with a leased steamer, the John Sherman, on May 31, 1875. Pictured is the vessel's master, John W. Stewart, (1843–1919), who for many years was one of the leading captains on the Great Lakes. (Courtesy of Jill Spinelli.)

Pro. No._____ Freight Office, Flint & Pere Marquette Railway Co.,

M _Gillett & Goodsell_ _Ludington_ Station, _Sept 28_ 187 5

To THE FLINT & PERE MARQUETTE RAILWAY COMPANY Dr.

For transportation from _Sheboygan_

All claims, for which this Company is liable, must be made in writing to the Freight Agent, within twenty-four hours after delivery of the Freight.

NUMBER AND DESCRIPTION OF PACKAGES.	Weight, lbs	Rate.	Freight.	Back Charges.	Total to Pay.
20 Bres Lime		15	3 00		
		20 ye	60		3 60

29/9/ 187 5. Received Payment. _R. Arnott_ Freight Agent.

This bill lists a consignment of lime shipped from Sheboygan to Ludington on the *John Sherman* for the hardware firm of Gillett and Goodsell on September 28, 1875. It bears the signature of the F&PM agent at Ludington, Robert Arnott, a Scottish immigrant who went on to prominence as an insurance agent. (Author's collection, gift of Jerry Cole.)

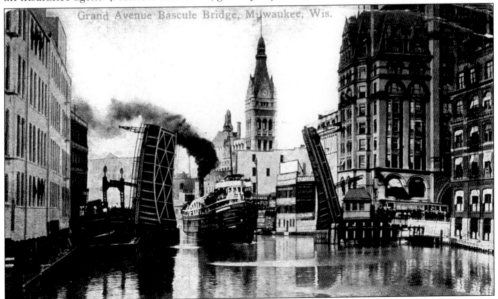

From 1876 to 1883, the Goodrich Line had the contract to provide steamship service between Milwaukee and Ludington for the railway. The best-known ship of this contract operation was the *City of Ludington*, built in 1880 at Manitowoc, Wisconsin. Seen at Milwaukee around 1896, the *City of Ludington* was remodeled in 1898 and renamed *Georgia*. (Author's collection.)

Early on June 29, 1876, Luther H. Foster discovered burglars leaving his house at the northwest corner of Ludington Avenue and Main Street (now Gaylord). Unwisely, he chased the burglars outside, where he was shot to death on the darkened street. It was no random burglary, for the intruders had taken a specific ledger. In retrospect this came to be known as "Foster's Black Book," with the implication that he had been about to expose corruption in the same manner as the *Wisconsin Black Book* of 1856. This may explain why the crime was long a taboo subject in Ludington. The assassins were never brought to justice, and it remains as much a mystery today as in 1876. (Fred Silver photograph, courtesy of the late Doris Foster Lessard.)

Frank Foster's diary entry from June 29, 1876 reads: "Mother woke me up this morning about 3 o'clock saying that Father had chased a burglar out of the house and there had been a pistol fired, then a cry of murder. We went out to see what the trouble was and after searching about ten minutes found Father—dead—shot three times—by the person he had followed out of the house. We have passed a dreadful day." (Courtesy of the late Doris Foster Lessard.)

JUNE, THURSDAY 29. 1876.

Mother woke me up this Morning about 3 o'clock saying that Father had chased a Burglar out of the house & there had been a pistol fired, then a cry of murder. We went out to see what the trouble was & after searching about ten minutes found Father— dead— shot three times— by the person he had followed out of the house. We have passed a dreadful day—

FRIDAY 30.

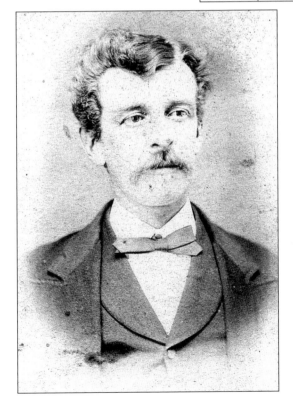

After only a year at the University of Michigan, Frank A. Foster (1856–1924) returned to Ludington in 1878 to look after matters related to his father's estate. He then embarked on a career that included lumbering, working as a railway mail agent, conducting an insurance agency, and serving four terms as county treasurer and three as county Republican chairman. (Courtesy of the late Doris Foster Lessard.)

State of Michigan, County of Mason, City of Ludington,

City Treasurer's Office, _Dec 19th_ 1879

Received of _F. A. Foster_

The sum stated below for Taxes assessed upon the following described tracts of land in said city for the year 1879.

Ward.	Lot.	Block.	State Tax.	County Tax.	Contin-gent.	Road Tax.	School Tax.	Special.	Rejected.	RECAPITULATION.
1	4, 11 & 12	10	18	72	30	30	60	15		
1	4	14	15	60	23	23	50	12		Rejected.....$..........
1	1 & 2 A, 6 & 10	30	360	1440	566	566	1200	288		Special Tax.$ _5.32_
2	8	20	09	36	14	14	30	07		School Tax.$ _25.15_
1	1 & 2	47	15	60	23	23	50	12		Road Tax.$ _10.40_
4	8	94	52	210	82	82	175	42		Contingent..$ _10.40_
4	8 & 9	95	07	30	12	12	25	06		County Tax.$ _26.08_
4	11 & 10	95	09	36	14	14	30	07		State Tax..$ _6.63_
3	13 & 14	128	14	60	24	24	50	12		Collection..$ _1.82_
1	1 & 2 A, 9 & 12	144	1674	654	257	257	540	131		Total.... $ _83.40_

L. C. Waldo

CITY TREASURER.

This statement lists property taxes paid in 1879 by Frank A. Foster in all four city wards for a total tax of $83.40. The lots in Block 30 of the First Ward included the family home at the corner of Ludington Avenue and Main Street (now Gaylord). The receipt bears the signature of City Treasurer L. C. Waldo, one of the city's leading lumbermen. (Author's collection, gift of the late Doris Foster Lessard.)

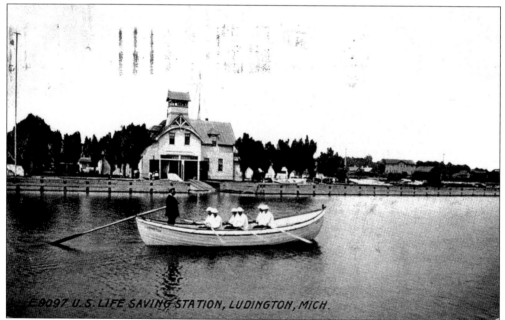

E 9097 U.S. LIFE SAVING STATION, LUDINGTON, MICH.

A lifeboat station was built at Ludington by the United States Life-Saving Service in 1879. Designed by government architect J. Lake Parkinson, it was erected by local builders August Tiedemann and Charles Boerner. Seen here in 1906, the building was razed in 1933 for construction of a new station, completed in 1934. The present Coast Guard station was built to the west of the 1934 station in 2004. (Author's collection.)

A Welsh immigrant, Thomas E. Davies (1843–1915) purchased the Ludington Boiler Works in 1878 from Thomas P. McMaster, its owner since 1874. Located at the northeast corner of Charles (now Rath) and Foster Streets, the shop manufactured boilers, smokestack pipe, and similar metalwork. Davies later formed a partnership with his brother, John H. Davies (1858–1925), to whom he sold the shop in 1901. It burned in 1916. (Courtesy of Walter Hornberger.)

Many of Ludington's mill workers and loggers were immigrants, chiefly from Scandinavia, Germany, Poland, Bohemia, the British Isles, and Canada. Pictured in this c. 1880 tintype are Danish immigrants James Madison and James A. Rye (seated) with an unidentified friend. Rye later left the woods for a mercantile career and was proprietor of the Busy Big Store from 1901 to 1928. (Author's collection.)

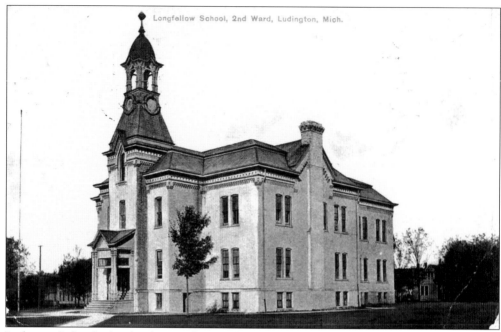

Ludington's first high school was a frame schoolhouse built in 1867 on Ludington Avenue. A brick high school was built in 1879–1880 on Court Street at a cost of $10,000. In 1888 it became the Second Ward School, later called Longfellow School. Seen here around 1909, it was closed in 1966 and razed in October 1976 to allow construction of Longfellow Towers Apartments. (Author's collection.)

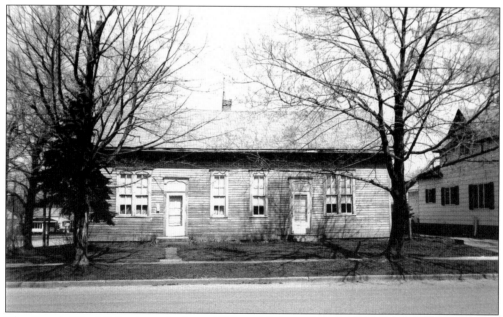

The Fourth Ward School was built in 1880 on Madison Street. It was moved to 401 Fourth Street and converted into a dwelling when a new school was built in 1886. The author's great-grandparents lived in the house with their five children around 1912. The house is shown in October 1988, five years before it was extensively modernized.

Five

THE HIGH OLD 1880s

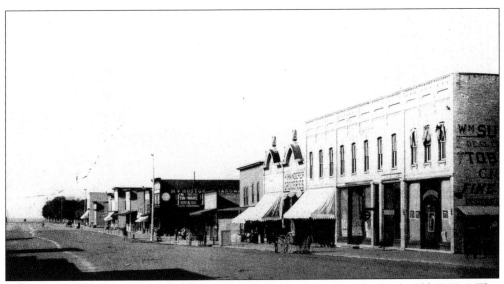

The late Cleveland Amory called this under appreciated decade "the High Old 1880s." This 1888 view of Ludington Avenue west from Charles Street (now Rath) is representative of the decade. At far right is the O'Hearn Block, built in 1883; most of the other buildings date from 1867 to 1876. The last building before the trees is George Tripp's grocery store, built in 1882. (Author's collection.)

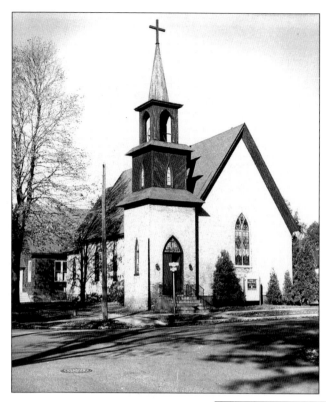

The great fire of June 11, 1881, necessitated the rebuilding of much of the business district as well as the Congregational Church and Grace Episcopal Church. Located on Court Street, the second Grace Church was built in 1881 and 1882; Guild Hall was added in 1895. The buildings are pictured virtually unchanged in the 1960s. Both were razed in 1969 when the parish moved to its present building on James Street. (Author's collection.)

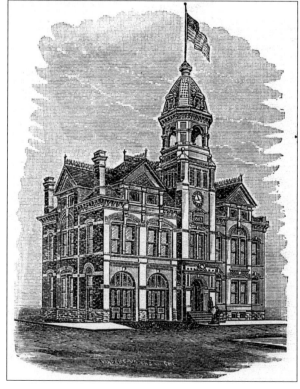

As the Ludington City Hall also burned on June 11, 1881, a new structure was erected in 1883 at the northwest corner of Charles (now Rath) and Loomis Streets. It was designed and built by Tiedemann and Boerner at a cost of $17,000. On the ground floor was the downtown fire station (a second fire station was built in the Fourth Ward in 1884). This city hall was razed in 1949. (Author's collection, gift of the late Doris Foster Lessard.)

Much of the city's post-fire architecture was the work of August Tiedemann and Charles Boerner, who were in business together from 1874 to 1892. A German immigrant, Boerner (1846–1926) came to America in 1863 and settled in Ludington in 1868. He was succeeded in business by his son, Frank Boerner. (Author's collection, W. G. Melville photograph.)

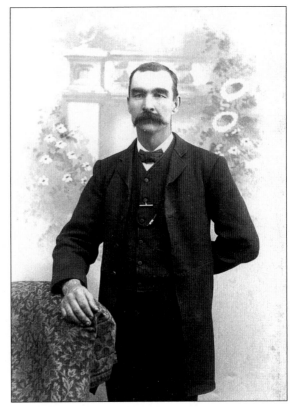

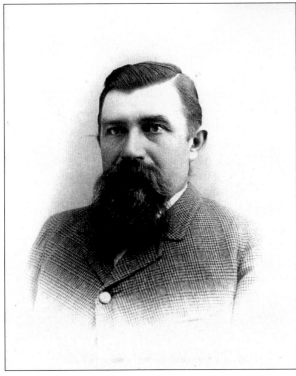

Also a German immigrant, August Tiedemann (1851–1933) came to America in July 1870 and settled in Ludington in 1872. He distinguished himself as an architect and builder with designs ranging from high-style Victorian buildings like the 1883 city hall to modern industrial structures like the F. Mayer shoe factory of 1920. He also designed numerous residences. (Author's collection, W. G. Melville photograph.)

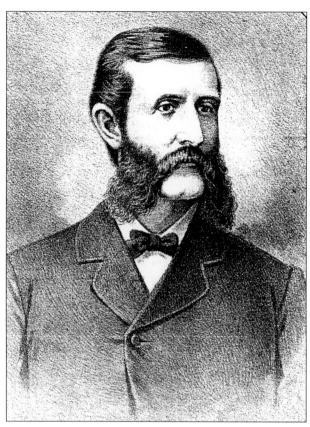

A native of Erie County, New York, George N. Stray (1849–1926) came to Ludington in March 1870 as storekeeper for Danaher and Melendy. He was named cashier of the First National Bank in 1882 and served as president from 1895 to 1910. Stray was mayor of Ludington in 1882 as a Democrat, but later became a Republican over the silver issue. After 1914, he was a resident of San Jose, California. (Author's collection.)

Ludington's foundries included the Ludington Iron Works, operated by George Goodsell from 1875 to 1897, and the Industrial Iron Works. The latter was built in 1882 by Robert B. Patterson at 502 South James Street. Patterson formed a partnership with his son-in-law, Eugene C. Rohn, in 1903. The foundry was razed in 1919 to allow construction of the F. Mayer shoe factory. (Author's collection, gift of the late Doris Foster Lessard.)

In her widowhood, Mrs. Luther H. (Lucy Amelia) Foster (1832–1915) was the leader of fashionable society in Ludington. She intensely disliked being photographed. All the photographs taken of her were formal portraits, carefully controlled, and as in this case, retouched. (Fred Silver photograph, courtesy of the late Doris Foster Lessard.)

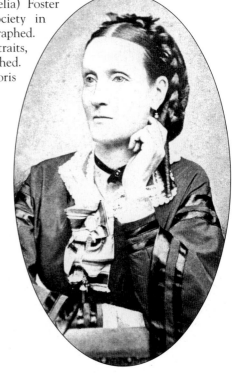

Foster's chief rival for leadership of local society was her sister-in-law, Mrs. Edward A. (Laura) Foster (1835–1896). The rivalry ostensibly ended with the departure of the E. A. Fosters for Wisconsin in 1885, but the animosities of those years died hard. As late as 1935, Doris Foster was snubbed by one of her father's first cousins at Epworth. (Author's collection, Fred Silver photograph.)

Seen here as a railway mail agent around 1883, Frank A. Foster was, as the son of Luther H. Foster, one of the luminaries of local society. His first wife, Charlotte Patterson Wood, died in 1905. He remarried in 1908, but his second wife, Hedwig Tiedemann, was not approved of by his imperious mother. (Courtesy of the late Doris Foster Lessard.)

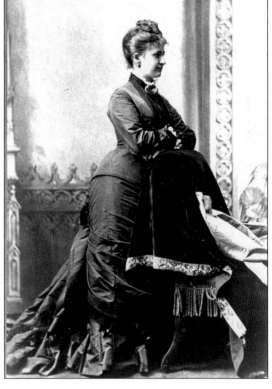

The strong-willed and socially ambitious Charlotte Patterson Wood (1858–1905) married Frank A. Foster at East Saginaw on June 11, 1884. The daughter of Sen. Alfred B. Wood, she was kin to Elizabeth Patterson, first wife of Jerome Bonaparte. "Lottie" consciously imitated her famous kinswoman's Empire hairstyle. (Courtesy of the late Doris Foster Lessard.)

Frank and Charlotte Foster lived in this understated house at 110 North Lavinia Street. It was built in 1871 by Ludington's first mayor, Charles E. Resseguie, a lumberman. Designated as a State Historic Site in 1974, the house remained in the family until its sale in 2004. (Courtesy of the late Doris Foster Lessard.)

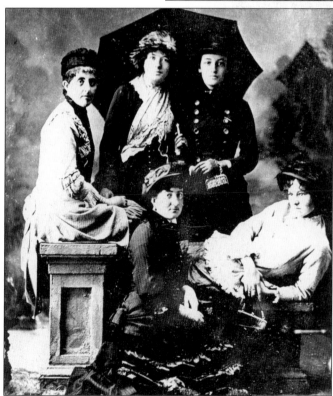

As the daughter of Joshua and Sarah (Foster) Allen, Mrs. Frank N. (Fannie) Latimer acted as a moderating influence on her rather difficult cousins. Here she is seen with four of her cousins in the 1880s. They are as follows, from left to right: (seated) Mrs. Latimer, Emma (Stanchfield) McMahon, and Charlie (Hutchins) McMahon; (standing) May (Foster) Baker and Alice (Foster) Gary. (Courtesy of the late Doris Foster Lessard.)

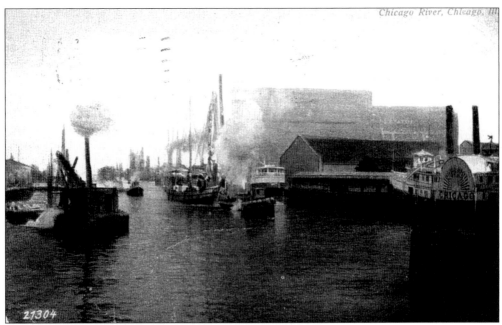

"A fleet of white-sailed ships," wrote Frances Caswell Hanna in 1955, "escorted in and out of the harbor by puffing tugs, carried lumber across the lake. Pine was king. Chicago was the greatest lumber market in the world. And Ludington was closely related to Chicago." In this 1884 image, a schooner is being towed into Chicago. At right, the steamer *Chicago* is at the Goodrich Line dock. (Author's collection.)

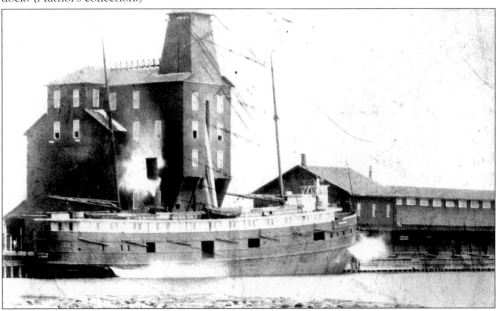

Steamship service to Milwaukee was also of prime importance. The Flint and Pere Marquette built a grain elevator at Ludington in 1877, followed by a freight shed in 1878. Between 1882 and 1890 the railway built five package freighters with passenger accommodations, known as the "Black Boats" for their hull color. Here the *F&PM No. 3*, built in 1887, is seen at the Ludington grain elevator in 1890. (Courtesy of the late Doris Foster Lessard.)

Born in Cattaraugus County, New York, Daniel W. Goodenough (1842–1921) came to Ludington in 1872. After his general store burned down in June 1875, he plunged into the lumbering business, getting out ties, posts, and poles. In 1884, he was caught in the crash of the New York and West Shore Railroad, to which he had supplied ties. Forced into bankruptcy, he was later able to repair his fortunes. (Courtesy of the late Doris Foster Lessard.)

A native of Denmark, Rasmus Rasmussen (1850–1921) settled in Ludington in 1876. He built a hotel, the Lake House, in 1877. Nicknamed "Old Denmark," Rasmussen was the outstanding local dealer in hemlock. He dealt in ties, wood, and bark, shipping his product on the schooner *Abbie*. Here he is seen around 1880 in an ink portrait over a photograph, with highlights in chalk and watercolors, by Fred Silver. (Author's collection, gift of Jack Holzbach.)

A Danish immigrant, Nels P. Christensen (1850–1897) established himself in the dry goods business in the Fourth Ward in 1880. In 1887, he erected a store building that still stands at 925 South Washington Avenue. He purchased the store of Mrs. A. Larson at 126 West Ludington Avenue in 1891. Christensen closed both stores in 1895 when he acquired the Busy Big Store, which he operated until his death. (Author's collection, Fred Silver photograph.)

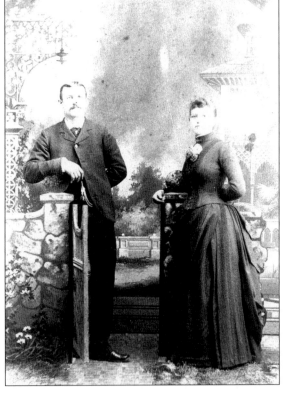

Tom Ford (1854–1923) was one of Ludington's leading grocers from 1879 until 1918. During that time his store was located at 220 (later 212) West Ludington Avenue. Well known as a practical joker, his prankish personality is perhaps evident in his portrait with his wife, the former Mary Surplice. (W. G. Melville photograph, courtesy of Jim Fay.)

Pictured here are the children of Lewis C. Waldo and his wife, the former Minnie Roby. Frances Caswell Hanna, herself only a little older than the Waldo children in the 1880s, recalled in 1955: "There were several young children in the family who were frequently met driving their burro and cart over the sawdust streets." (Fred Silver photograph, courtesy of Julie Rye Himebaugh.)

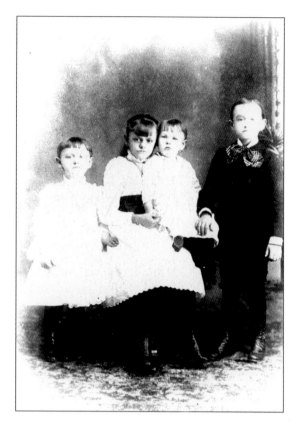

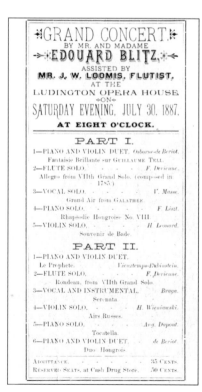

The Ludington Opera House was built in 1884, the proprietors being four lumbermen, John D. Hoogstraat, Thomas Neilan, John Joyce, and Patrick Butler, and two hardware merchants, B. J. Goodsell and Joseph Lohner. Its best-known manager was U. S. Grant (1863–1910), who was named in honor of General Grant. Here a handbill advertises a concert of July 30, 1887. The opera house was rebuilt as the Lyric Theater in 1910. (Author's collection, gift of Jack Holzbach.)

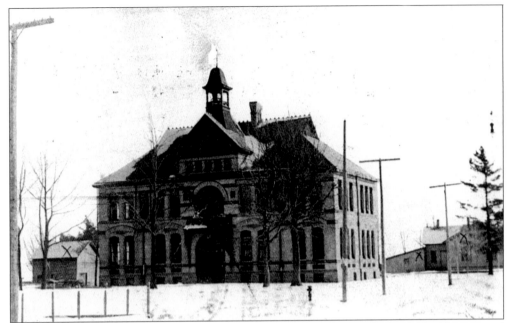

In 1886, a new Fourth Ward School was built on Madison Street, with the old building moved to Fourth Street. The new building was designed and built by Tiedemann and Boerner. Named Pere Marquette School in 1896, it is seen around 1908 with the 1880 school building visible in the background at right. Pere Marquette School was razed in 1965 and replaced with a one-story building. (Courtesy of Jerry Cole.)

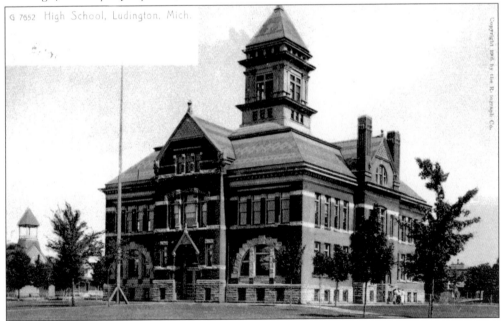

With the rapid growth of the city, a new high school was built in 1887–1888. The architect was Fred W. Hollister of East Saginaw. It is seen here in 1905. Large additions were built in 1925. Used as a junior high school from 1958 to 1964, the 1888 building was razed in 1968, with the 1925 portions renovated as Foster School. (Author's collection.)

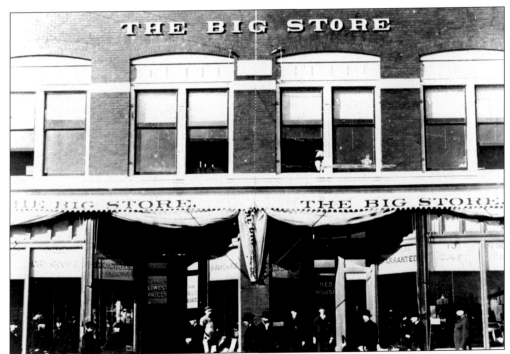

In 1888, the Pere Marquette Lumber Company built the Busy Big Store at 103 East Ludington Avenue. The store became the property of the Big Store Mercantile Company in 1892. It passed through various ownerships, most notably that of James A. Rye, who owned it from 1901 through 1928. Leased as a Montgomery Ward store from 1928 to 1980, the building remained in the Rye family until 1979. (Courtesy of Gail Lyons.)

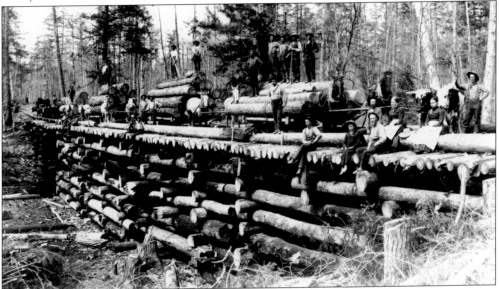

As the 1880s progressed, lumbermen drove ever deeper into the pine forests in search of marketable timber. Increasingly, they cut hardwoods and hemlock, varieties they had heretofore disdained. Here a logging crew, including two female cooks, is seen on a log trestle with oxen, horse teams, and log loads. (Courtesy of Ed Briscoe.)

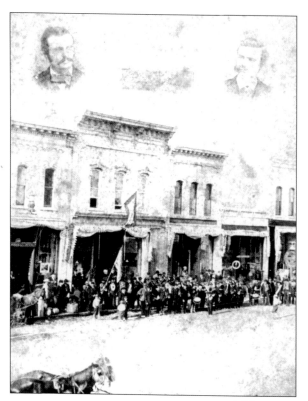

Members of the Knights of Honor are seen in front of their hall (displaying the flag) in the Pierce Brothers Block, around 1889. Above are vignettes of Frank B. and Newton B. Pierce, the building's owners. In 1889, the Ludington Avenue stores pictured were, from left to right, B. J. Goodsell and Company, hardware; Mrs. A. Larson, dry goods; W. C. Starr and Son, grocers; Dr. F. N. Latimer, drug store; and F. M. Ashbacker, men's clothing. (Author's collection, gift of Jerry Cole.)

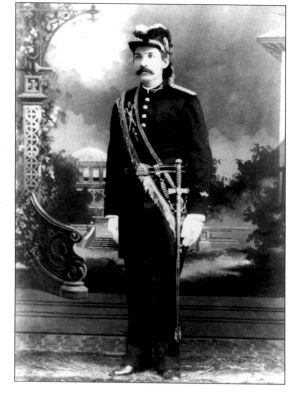

Freemasonry appealed to the middle and upper classes. The order flourished in Ludington and the Masonic Temple Association built its temple in 1888–1889. James A. Rye is seen in the uniform of the Knights Templar. Apollo Commandery No. 31, Knights Templar, was instituted January 31, 1882, and continued independently until 1975 when it was combined with Manistee Commandery No. 32. (Author's collection, W. G. Melville photograph.)

Six

EXODUS OF
THE LUMBERMEN

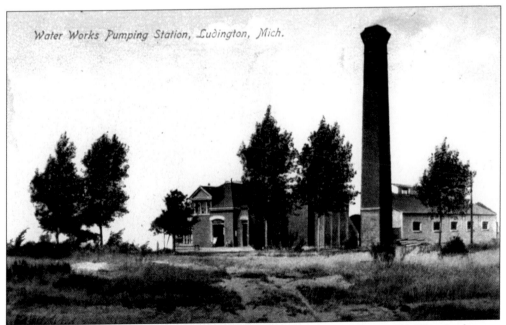

The Ludington Water Supply Company built a water works in 1882 at 801 West Ludington Avenue. It was replaced in 1892 by this facility on Amelia Avenue (now Lake Shore), which the city acquired when it assumed the obligation of the company's bonds in November 1899. Ironically, the original building still stands, whereas the 1892 water works was replaced in 1970 and razed in 1972. (Author's collection.)

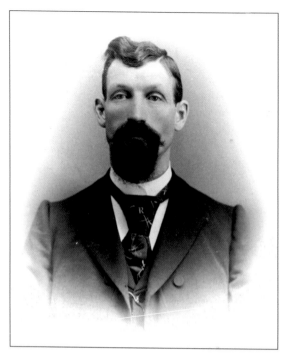

In 1890, a promoter named Goldsborough sold stock in a fraudulent copper-mining venture to a number of unwary local investors. The scheme is today remembered mainly because William Rath (pictured here) lost so much that he was forced into bankruptcy. He repaired his fortunes, however, later serving as collector of customs, president of the Ludington Board of Trade, mayor of Ludington, and at his death in 1916, was the president of Epworth Assembly. (Author's collection.)

Seen here around 1890, the Kieswalters were one of Ludington's leading merchant families. Pictured are, from left to right, (first row) William Kieswalter, Carrie Kieswalter, and Katharine Kieswalter; (second row) John Kieswalter and Elizabeth Kieswalter. William had a grocery store from 1867 to 1902; he closed it after his wife's suicide. He operated a feed store until his death in 1910. The business was discontinued after the suicide of John Kieswalter in 1912. (Author's collection.)

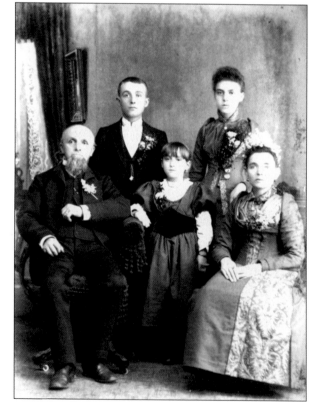

Built by Roswell P. Bishop in 1892 at 302 North Harrison Street, this house was a showplace during his tenure in Congress from 1895 to 1907. In design, an eclectic mix of Georgian Revival, Greek Revival, and Second Empire elements, it is seen in 1926 when it was the home of Claude M. Curtiss, long-time circuit court stenographer. In 1945, it became the rectory of Grace Episcopal Church. (Courtesy of Grace Episcopal Church.)

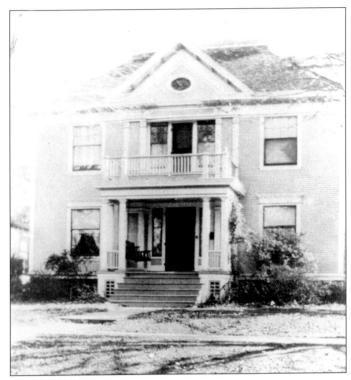

Ludington's first resident to be a presidential elector was the lumberman Justus S. Stearns in 1892. Warren A. Cartier was an elector in 1908. The Rev. Holden A. Putnam, minister of the Congregational Church, received the honor in 1916. The only local Democrat to be an elector was Mollie Mahoney Danaher, adopted daughter of M. B. Danaher, in 1936. More recently, Anne Schwaibold was a presidential elector in 1980. (Courtesy of Mason County District Library.)

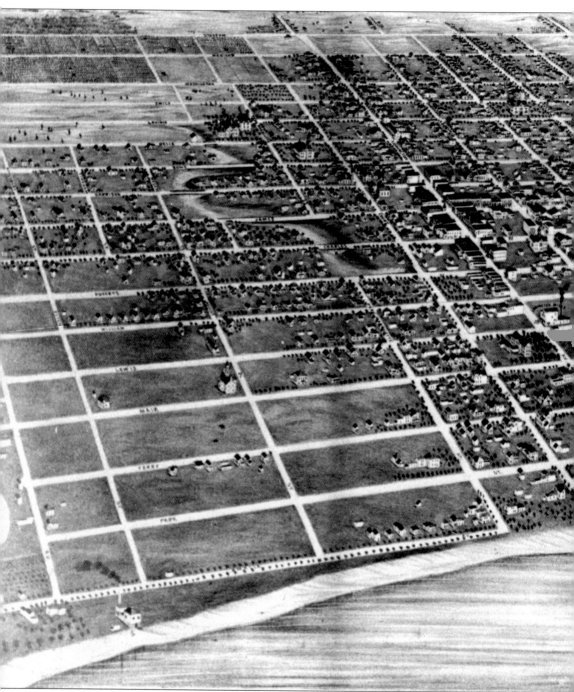

This lithograph depicts Ludington in 1892, the year the Citizen's Development Company attempted to start the city's post-lumber industrial development by platting the Manufacturers' Addition on a spur of the Flint and Pere Marquette Railroad. Mayor Lucius K. Baker proclaimed July 14, 1892, a public holiday. He joined Congressman Harrison H. Wheeler and Charles G. Wing, president of the development company, in leading a parade to the new subdivision, where a barbecue and

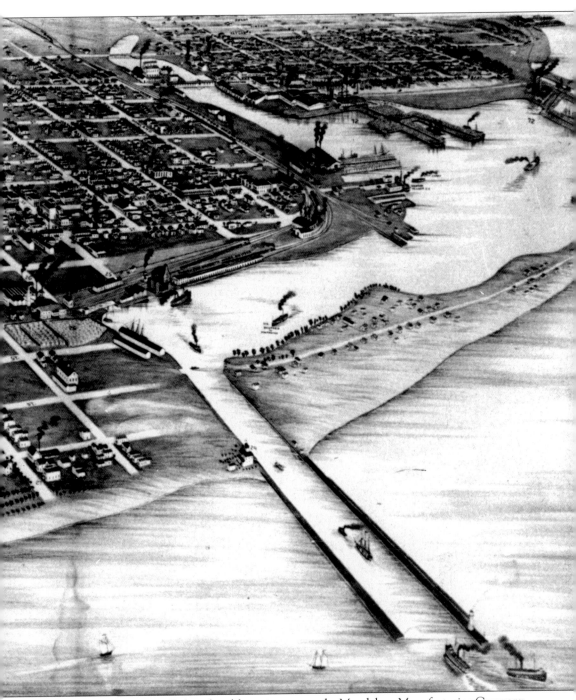

auction were held. Four small, short-lived factories came—the Mendelson Manufacturing Company (which made men's trousers), E. G. Whitacre Manufacturing Company (turned and enameled wood products), Standard Cloth Company (manufactured window shades), and the Ludington Radiator Manufacturing Company. All four were brought down by the failure of the Commercial and Savings Bank of Ludington in 1894. (Courtesy of James Goulet.)

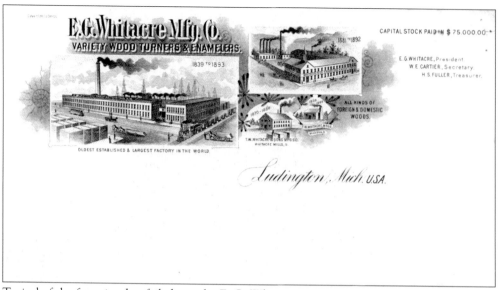

Typical of the factories that failed was the E. G. Whitacre Manufacturing Company. Founded in 1839 in Minerva, Ohio, it moved to Ludington in 1892. This engraving depicts the growth of the company with the Ludington plant pictured at left. The railroad siding and streetcar line depicted in the engraving were never built, as the company did not last long enough to build them. Financed by the Commercial and Savings Bank, it fell with that bank in 1894. (Author's collection.)

The financial panic of 1893 did not dampen enthusiasm for the world's fair held that year in Chicago. Captain Charles Tufts and the Ludington crew represented the United States Life-Saving Service at the fair. This is the photograph identification of Surfman No. 1 Jason F. Pratton (1854–1921) while serving at the exposition in 1893. The Ludington crew also appeared at the Cotton States Exposition in Atlanta in 1895. (Courtesy of Hazel Christie.)

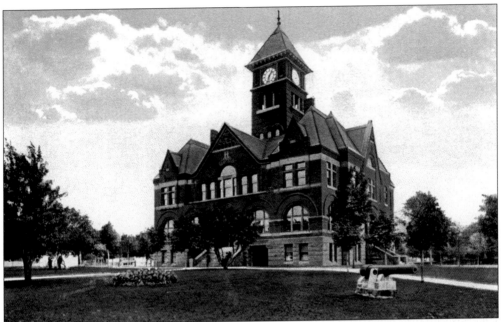

When Ludington was chosen as the county seat in 1873, a small county building was erected, but it soon proved inadequate. The present courthouse, designed by Sidney G. Osgood of Grand Rapids, was built in 1893–1894 on Ludington Avenue at a cost of $70,000. The tower clock was installed in 1906. The two cannon on the lawn, relics of the Spanish-American War, were scrapped in 1942. (Author's collection.)

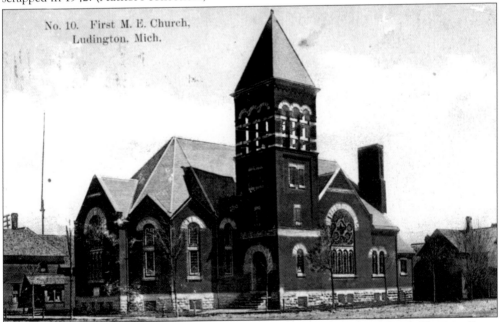

No. 10. First M. E. Church,
Ludington, Mich.

This building was erected for the First Methodist Episcopal Church at 109 South Harrison Street from 1893 to 1895. (The original church, built in 1872, was moved in 1895 to 1014 South Madison Street, where it presently serves as the Danish Hall.) A large addition to the church was built in 1926; since 1968 it has been the Ludington United Methodist Church. (Author's collection.)

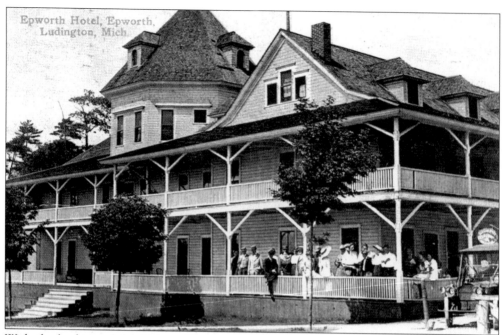

With the backing of the Citizens Development Company and the Flint and Pere Marquette Railroad, Epworth Heights was established in 1894 as a Methodist Chautauqua resort. One of the resort's most popular destinations was the Hotel Epworth, which had spacious porches and a restaurant. It was built in 1894–1895 facing Lake Michigan. The hotel was remodeled in 1976 as a museum and community center. (Author's collection.)

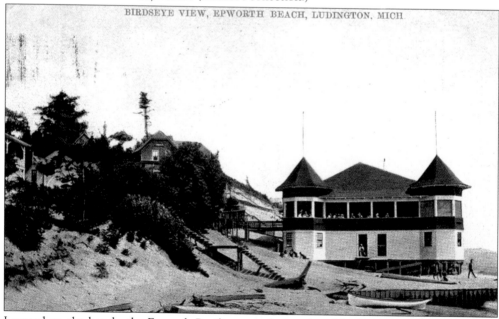

Located on the beach, the Epworth Pavilion was designed and built in 1894–1895 by August Tiedemann, who was fond of steeply sloping roofs and corner turrets. The pavilion burned in 1943. The cottage of Willis W. Cooper, who died in the Iroquois Theater fire in Chicago in 1903, is seen directly overlooking the pavilion. (Author's collection.)

As secretary of the Epworth Assembly from 1895 to 1915, Grand Rapids attorney Elvin Swarthout (1864–1935) was *de facto* manager of the resort during those years. Often he greeted newcomers at the Epworth train platform. Swarthout served as mayor of Grand Rapids from 1924 to 1930. (Author's collection, Noble photograph.)

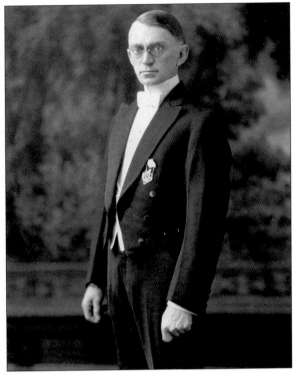

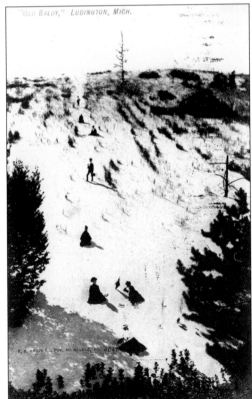

Located north of Epworth was a huge sand dune, said to be even larger than the famous Hoosier Slide at Michigan City, Indiana. Known variously as Mount Baldy, Old Baldy, and Bald Knob, it was popular with residents and resorters alike for climbing and picnicking. In 1916, however, the Hubbell Sand Company began extracting sand from the dune, and by 1931 Mount Baldy was no more. (Courtesy of Jerry Cole.)

75

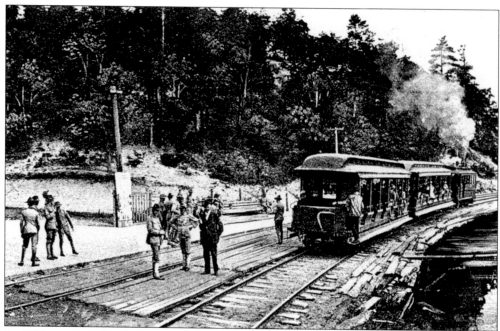

In 1895, a group of Ludington businessmen organized the Epworth League Railway to provide passenger service between Ludington and Epworth. It was called the "Dummy" because its steam locomotives were built with a false exterior so as to avoid frightening horses on city streets. Acquired by J. S. Stearns, the company was reorganized as the Ludington and Northern Railway in 1901 and extended to new resorts at Hamlin Lake. (Author's collection, gift of Fred and Pat Slimmen.)

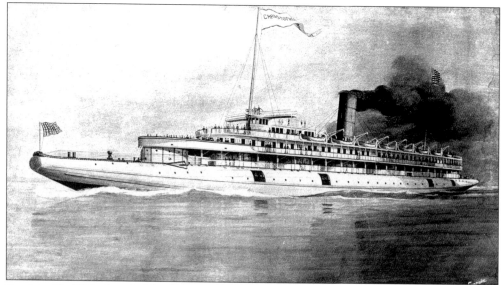

On July 20, 1896, the whaleback passenger steamer *Christopher Columbus* of the Hurson Line visited Ludington with an excursion from Milwaukee. Seen here in an 1893 lithograph, the *Columbus* was built for the Chicago World's Fair of 1893. From 1894 to 1931 it sailed between Chicago and Milwaukee; after 1898 the steamer sailed in the fleet of the Goodrich Line. The *Columbus* was scrapped in 1936. (Author's collection.)

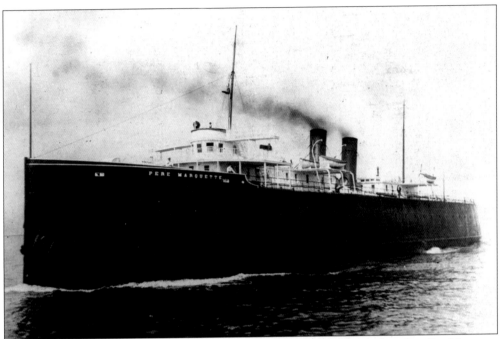

The economic gloom of the 1890s began to clear when the F&PM had the steel car ferry *Pere Marquette* built to carry passengers and railroad freight cars between Ludington and Manitowoc, Wisconsin. Launched at West Bay City on December 30, 1896, the *Pere Marquette* arrived at Manitowoc on her maiden voyage from Ludington on the morning of February 17, 1897. Joseph Russell was captain with Robert MacLaren as chief engineer. (Courtesy of the late Doris Foster Lessard.)

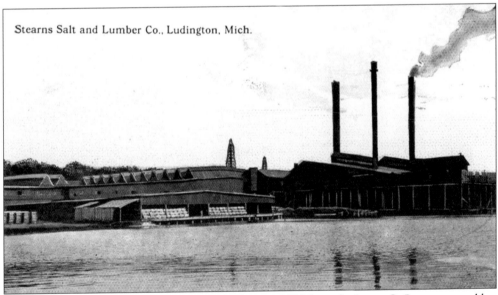

The purchase of Lyon's north mill and salt plant in 1898 brought Justus S. Stearns to sudden prominence. This mill, together with that at Stearns Siding, built in 1880, made him the largest manufacturer of lumber in Michigan. His mills produced 125 million board feet in 1898. Stearns was elected secretary of state of Michigan on November 8, 1898. (Author's collection.)

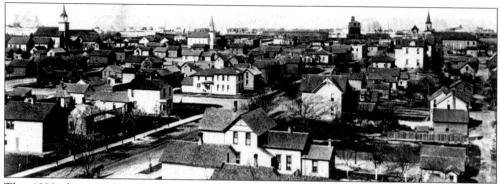

This 1898 photograph provides a southwest view from the high school on Foster Street. The churches visible are, from left to right, St. John's German Lutheran, Emanuel Swedish Lutheran, and St. Simon Roman Catholic. Other landmarks are the F&PM freight shed and grain elevator and Emerson school. Note the unpaved streets, board sidewalks, and unpainted houses. (Courtesy of Jack Holzbach.)

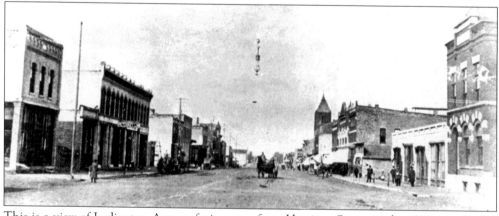

This is a view of Ludington Avenue facing west from Harrison Street in the 1890s. At far left is the Kieswalter Block, built in 1881 and razed in 1964. The buildings with Venetian Gothic windows are the Wing Block and the Stout Block; both were built in 1881 and burned in 1901. At the far right is the Pere Marquette Club (today the Elks Temple), built in 1891–1892. Note the overhead electric carbon-arc lights. (Courtesy of Gail Lyons.)

Even before the death of Queen Victoria on January 22, 1901, it was evident that a great age was drawing to a close. (Here she is seen receiving President Grant at court in 1877.) The passing decades had seen vast political, social, and technological change, prompting Henry Adams to formulate his theory of acceleration of history. The queen's demise was keenly felt by her local kin, the Fosters. (Author's collection.)

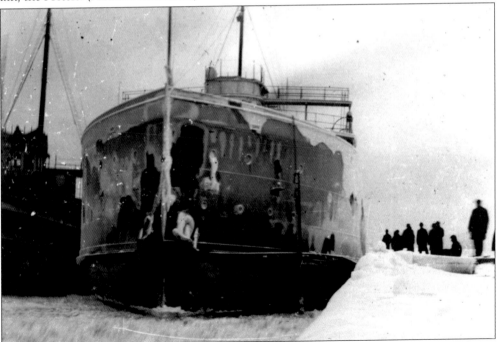

Here the *Pere Marquette*, with the *F&PM No. 5* alongside it, attempts to force its way through heavy pack ice into Ludington harbor in February 1899. Severe ice conditions impeded car ferry operations especially during the winters of 1899, 1900, 1904, 1912, and 1918. (Courtesy of Jack Holzbach.)

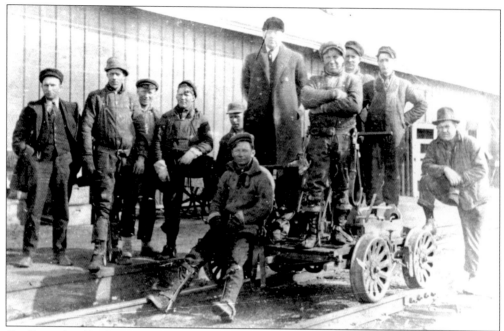

On December 7, 1899, President William W. Crapo and other officials of the F&PM visited Ludington on an inspection tour. Agent W. K. Tasker is seen at far left; Crapo is at center wearing a fur hat. The Pere Marquette Railroad took over the properties of the F&PM, the Chicago and West Michigan Railway, and the Detroit, Grand Rapids, and Western Railroad on January 1, 1900. (Author's collection.)

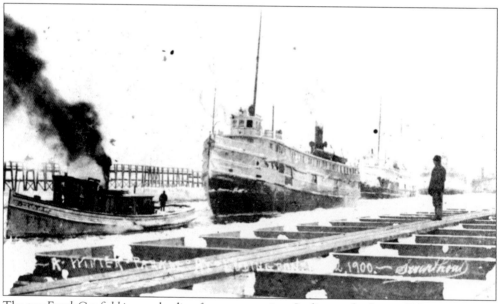

The tug *Frank Canfield* is seen leading four steamers into Ludington harbor on February 2, 1900. The steamers are the *F&PM No. 2*, *F&PM No. 3*, *Pere Marquette*, and *F&PM No. 4*. (In 1901 the package freighters were given "Pere Marquette" names with the same numbers.) The *Canfield* was wrecked near Big Sable Point on April 11, 1904, with the loss of three of its five-member crew. (L. F. Swarthout photograph, courtesy of Art Chavez.)

Seven

LUDINGTON-ON-THE-LAKE

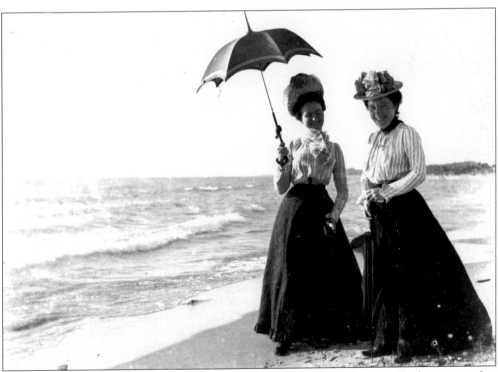

When Laura Freeman Stearns (wife of Robert L. Stearns) wrote the song "Ludington-on-the-Lake" at the end of the 19th century, it took its title from the city's location directly on Lake Michigan, unlike other West Michigan ports that are separated from the lake by barrier dunes. Here two Ludington ladies are seen around 1901 at the Lake Michigan beach (later presented to the city as Stearns Park). (Courtesy of Jack Holzbach.)

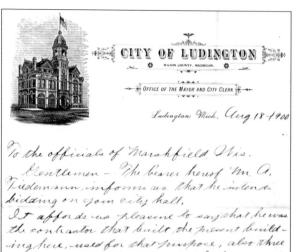

To the officials of Marshfield, Wis.

Gentlemen – The bearer hereof, Mr. A. Tiedemann, informs us that he intends bidding on your city hall.

It affords us pleasure to say that he was the contractor that built the present building here, used for that purpose, also three of the six school buildings which we now use. Should he be the successful bidder for your new city hall, you may be assured that you will have a complete job and done to your satisfaction, if plans and specifications are complete.

Yours truly
B. J. Goodsell
Mayor

Thos. Thompson Jr.
City Clerk.

When the builder August Tiedemann bid on the proposed city hall in Marshfield, Wisconsin, he obtained this testimonial letter signed by Mayor Bennett J. Goodsell and city clerk Thomas Thompson Jr. The Ludington officials praised his ability and cited his work on the city hall and school buildings. (Author's collection, gift of the late Doris Foster Lessard.)

This testimonial letter was written on the same occasion in 1900 and bears the signature of George N. Stray. The understated letterhead of the First National Bank lists the officers of the financial institution: George N. Stray, president; Amos Breinig, vice president; William L. Hammond, cashier; and Augustus D. Woodward, assistant cashier. (Author's collection, gift of the late Doris Foster Lessard.)

The First National Bank
OF LUDINGTON, MICH.

Ludington, Mich. Aug. 18th, 1900.

To whom it may concern,

This is to certify that Mr. August Tiedemann has been a resident of this city for more than twenty five years, that during this time he has been engaged as a contractor and builder, and has built some of our best business blocks and public buildings. Amongst the latter are the City Hall and two large public school houses. His work has given general satisfaction, and I can recommend him as a competent builder.

Geo. N. Stray.

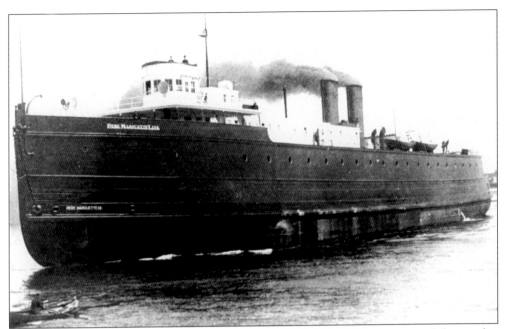

In the consolidation that formed the Pere Marquette Railroad, the company acquired the wooden car ferry *Muskegon*. Shifted in October 1900 from the Muskegon-Milwaukee route to sail between Ludington and Milwaukee, this vessel was renamed *Pere Marquette 16* in 1901. The ferry is seen travelling outbound at Ludington in 1902. (Courtesy of the late Doris Foster Lessard.)

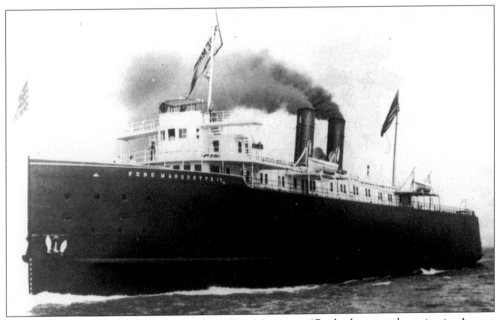

This is an early view of the steel car ferry *Pere Marquette 17*, which entered service in August 1901. Following this vessel into service were the *Pere Marquette 18* in 1902 and the *Pere Marquette 19* and *20* in 1903. The additions enabled the railroad to maintain sailings to Milwaukee and Manitowoc and establish a new route in 1903 to Kewaunee, Wisconsin. (Courtesy of the late Doris Foster Lessard.)

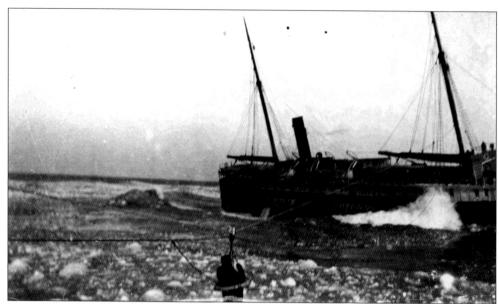

On January 17, 1902, the recently renamed *Pere Marquette 3* (formerly the *F&PM No. 3*) ran aground while traveling inbound at Ludington in a winter storm. All passengers and crew members were removed by the life-saving crew using the breeches buoy. Here a man is being rescued as the storm continues to bluster. The *Pere Marquette 3* was repaired at Milwaukee and returned to service. (Courtesy of Jack Holzbach.)

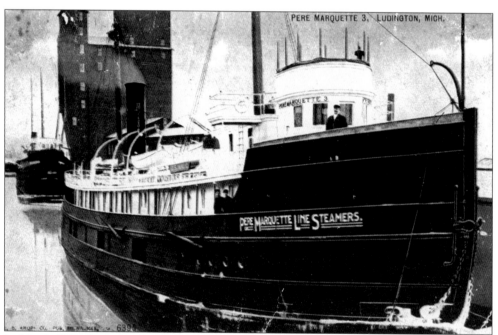

In March 1903, the railroad sold its Black Boats to a group of Manistee investors who established the Pere Marquette Line to operate the package freighters. Gustave Kitzinger was manager of the line until his death in 1929. The *Pere Marquette 3* is seen at the Ludington freight shed with the *Pere Marquette 4* at the grain elevator, which had been rebuilt after a fire in 1899. (Author's collection.)

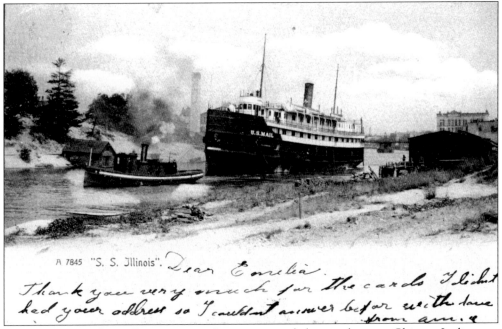

A 7845 "S. S. Illinois". *Dear Emelia.*
Thank you very much for the cards I didn't had your address so I couldn't answer befor with love from am.

The Northern Michigan Transportation Company provided service between Chicago, Ludington, and Michigan ports up to Mackinac Island. During A. E. Cartier's tenure as president of the line, 1903 to 1910, the fleet grew from two ships, the *Kansas* and *Illinois*, to include the *Missouri* (built in 1904), *Manitou* (purchased), *Manistee* (purchased), and *John R. Stirling* (leased). The *Illinois* is seen departing Manistee in 1905 behind the tug *John C. Mann*. (Author's collection.)

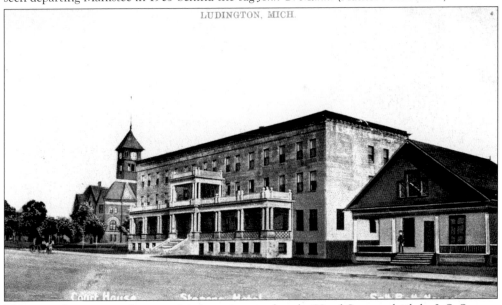

Many travelers arriving by steamship or train stayed at the Hotel Stearns, built by J. S. Stearns in 1903 at 210 East Ludington Avenue as the city's first modern hotel. Next door was a building occupied from 1903 to 1909 as a mineral bath house; later remodeled as the offices of the Stearns group of companies, it was razed in 1952. The former Hotel Stearns now operates as the Stearns Motor Inn. (Author's collection, gift of Judy Caldwell.)

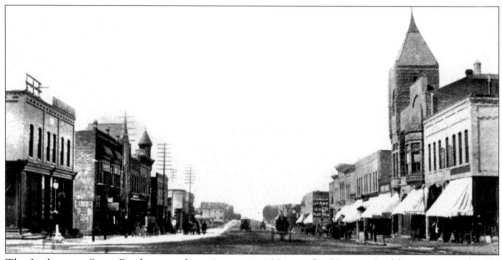

The Ludington State Bank opened on August 1, 1901, in the Huston Building, seen at the far left in this 1890s view. Its first president was Charles G. Wing (1846–1920), an attorney who lived on a 400-arce farm at the present site of the Mason County Airport and Western Michigan Fairgrounds. (Author's collection.)

James A. Rye (1863–1935), the Danish immigrant and former logger, purchased the Busy Big Store in 1901 in partnership with George E. Adams as Rye and Adams. In 1913 Adams' share was purchased by Frank Washatka. The firm of Rye and Washatka prospered, but the proprietors decided to retire in 1928, at which time the store was leased by Montgomery Ward and Company. (Courtesy of Julie Rye Himebaugh.)

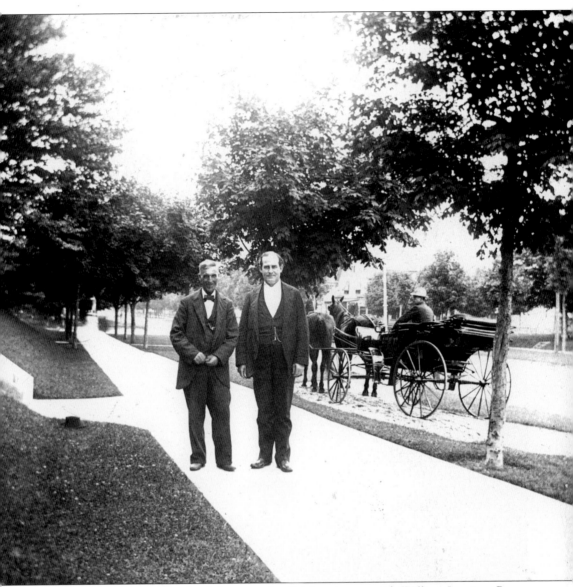

Here Thomas Burns (left), a local farmer and politician, is seen with William Jennings Bryan (1860–1925) in front of the Daniel W. Goodenough home at 706 East Ludington Avenue. At right is Goodenough's carriage and driver. Bryan was the leading figure of the Democratic Party for 30 years, receiving the presidential nomination in 1896, 1900, and 1908, and bringing about the nomination of Woodrow Wilson in 1912. Bryan was secretary of state in Wilson's cabinet from March 1913 to June 1915, resigning over the President's response to the sinking of the *Lusitania*. In contrast to his earlier political radicalism, at the end of his life, he was a spokesman for religious fundamentalism, most notably at the Scopes trial over the teaching of evolution in Dayton, Tennessee. Bryan is pictured on a private visit to Ludington, probably in 1902 when his friend Goodenough was the Democratic candidate for Congress. (Courtesy of the late Doris Foster Lessard.)

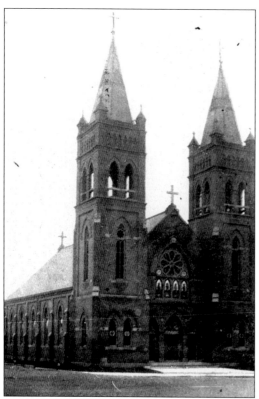

In 1902, St. Simon Roman Catholic Church erected a new building at the southwest corner of Foster and Harrison Streets. Its towers were a landmark for ships entering the harbor. The parish moved to a new building on Bryant Road in 1969, and the Foster Street building was razed in 1982. The present Ludington City Hall was built at this location in 1999–2000. (Author's collection, gift of Judy Caldwell.)

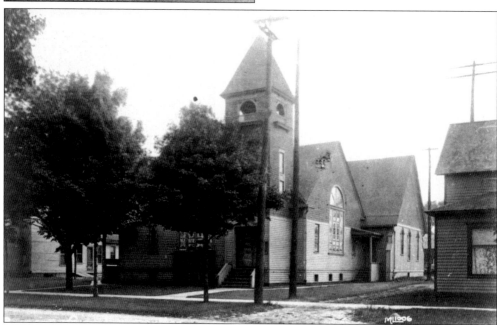

The Presbyterian church erected a new building in 1902 at 108 North Harrison Street, opposite the Congregational church. In 1924, the two were combined the form the Community Church. Used as a church hall, the former Presbyterian church was razed after construction of an addition to the Community Church in 1959. (Courtesy of Jack Holzbach.)

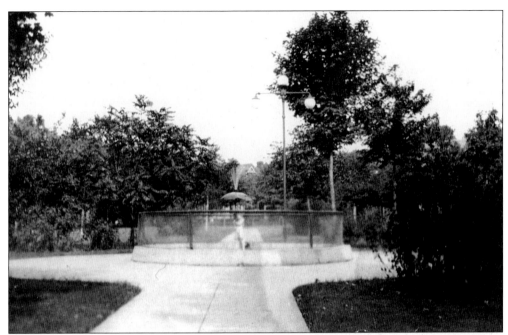

In 1899, the former site of the Filer House was acquired by the city and landscaped as City Park. James Foley donated a fountain that had long stood in the yard of his home. The fountain, which consists of a statue of a boy and girl holding an umbrella, is pictured standing in the park. Removed in 1976, it has been restored as a museum piece by the Mason County Historical Society. (Courtesy of Jerry Cole.)

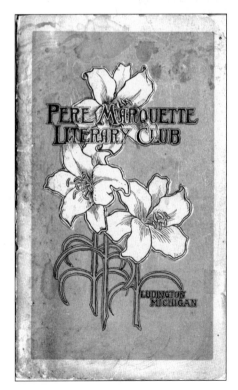

The first women's club in Ludington, the Pere Marquette Literary Club, was organized May 15, 1892, with Mrs. H. S. Fuller as president. At its weekly meetings, masterpieces of literature were reviewed, and papers read on history, literature, art, science, education, and current events. The cover of the club's 1905–1906 program combined the club's colors of white and gold with its emblem, the lily. (Author's collection, gift of the late Doris Foster Lessard.)

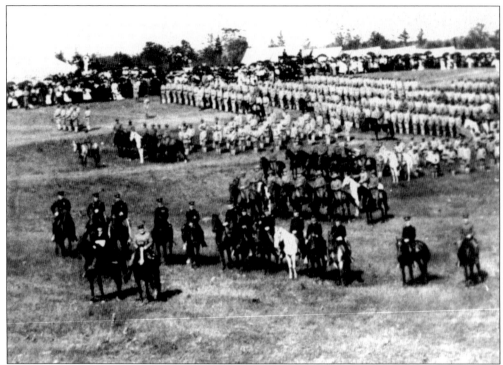

In 1904, the Michigan National Guard selected the Lincoln Fields north of Ludington as the site of its annual August encampment. This is part of the review of the guard on August 11, 1904. In the foreground at left are Gov. Aaron T. Bliss and Brig. Gen. Frederick D. Grant, eldest son of Pres. Ulysses S. Grant. (Courtesy of the late Doris Foster Lessard.)

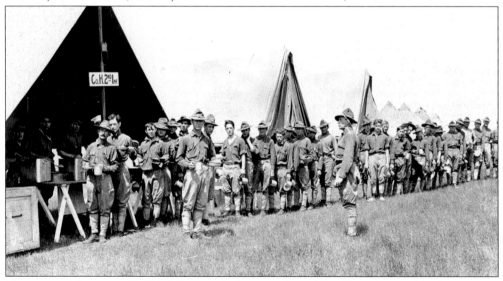

Here men of Company H, 2nd Michigan Infantry, a Grand Rapids unit, stand in line at mess call. Except for 1906 and 1908, when funds were lacking, the guard camped at the Lincoln Fields for two weeks each year from 1904 through 1912. In 1913, the guard accepted a site offered by Rasmus Hanson, a Grayling lumberman, and the encampments moved to Camp Grayling in Crawford County. (Author's collection.)

In November 1903, work began on a mansion for Warren A. Cartier at the northwest corner of Ludington Avenue and Lavinia Street. Completed in May 1905, it was one of the showplaces of the city. The house was purchased in 1951 by Abbie Schoenberger, the grocer. In recent years it has been the Schoenberger House bed and breakfast. (Author's collection.)

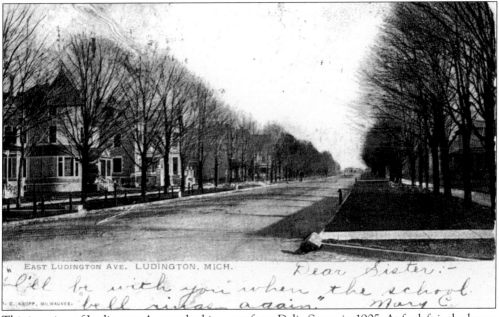

This is a view of Ludington Avenue looking east from Delia Street in 1905. At far left is the home of William L. Hammond, cashier of the First National Bank. The next building is the recently completed Warren A. Cartier mansion. On the next corner is the home of Cartier's father, A. E. Cartier, built in 1878 and today the Ludington House bed and breakfast. (Author's collection.)

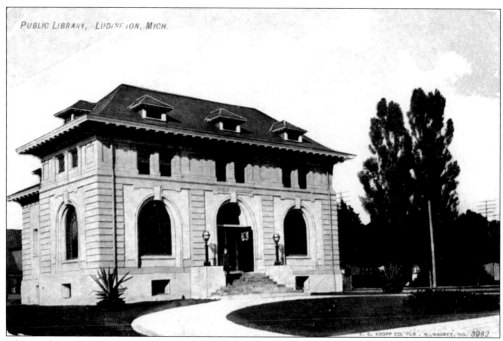

The Ludington Public Library (a Carnegie library) was built in 1905 at 217 East Ludington Avenue. It opened March 1, 1906, and is seen in that year with App M. Smith, a member of the library board, on the front steps. A large addition was built in 1976, and it became the Ludington branch of the Mason County District Library in 1994. (Author's collection.)

In 1907, J. S. Stearns offered his home, built in 1882 at 1109 South Washington Avenue, to the Mason County Hospital Association. The offer was accepted, and the building was given the name Paulina Stearns Hospital in memory of the donor's late wife. It is pictured shortly before its demolition in 1940 after a new hospital had been built across the street. The hospital moved to a new complex on Atkinson Drive in 1967 as Memorial Hospital. (Courtesy of Jack Holzbach.)

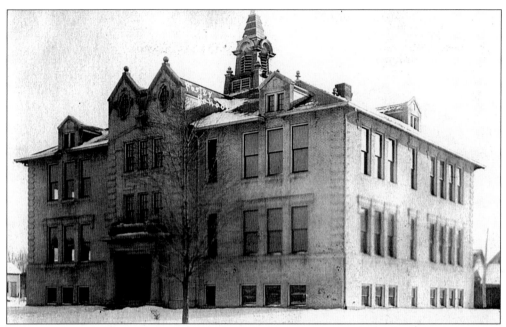

In 1905, a new elementary school was built in the densely populated Third Ward. The teachers voted to name the building Luther H. Foster School in honor of the assassinated lumberman who had been a school board member from 1868 to 1876. The building, pictured here in 1913, was razed in December 1966. In 1968–1969, the newer (1925) portions of the former high school were remodeled as Foster School. (Courtesy of Jerry Cole.)

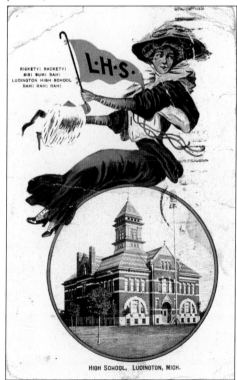

This 1909 postcard includes an illustration of Ludington High School with a young lady holding a school pennant and reciting the school cheer. The high school had already adopted the school colors of orange and black, and in 1913 its first *Oriole* yearbook was published. (Author's collection.)

In 1892, the Carrom game board was invented by Henry L. Haskell. After 1901, the Carrom plant was located in this building, erected in 1892 by the ill-fated Standard Cloth Company. Carrom moved in 1972 to Sardis, Mississippi. The old plant is home to FloraCraft Corporation today. Carrom boards are made in Ludington today by the "new" Carrom Company, established in 1961 as the Merdel Game Board Manufacturing Company. (Courtesy of Jerry Cole.)

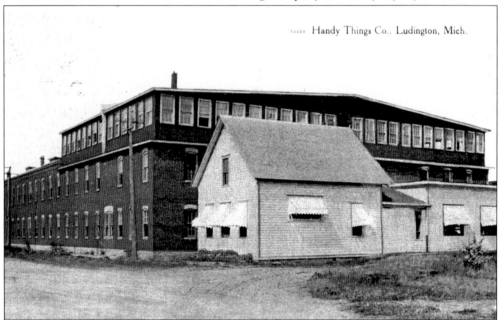

Following the failure of the E. G. Whitacre Manufacturing Company, the Cartier Enameling Company operated the plant. In 1901, the property was acquired by James R. Lane, who organized the Handy Things Company. When Lane died in 1911 the plant was acquired by J. S. Stearns, who sold it to Walter H. Pleiss in 1919. A new building was erected in 1930, but the subsequent owners closed the plant in 1981. (Author's collection.)

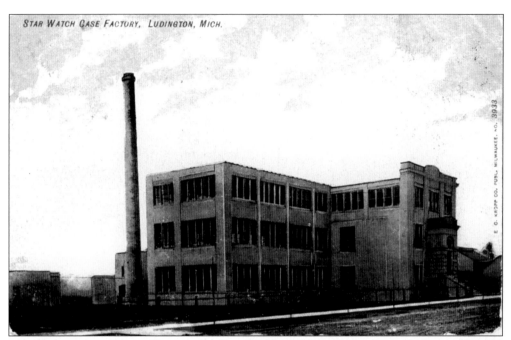

Moving here from Elgin, Illinois, the Star Watch Case Company opened its new $50,000 Ludington plant in 1906. Additions in 1909 and 1919 doubled and then quadrupled the plant's size. The plant closed in April 1982, and the building was razed in May 1995 to allow construction of Harbor Front Condominiums. (Author's collection, gift of the late Doris Foster Lessard.)

The new enterprises of the early 1900s brought new people to Ludington. Among those who came with the Star Watch Case Company was Frederick J. Hermann (1864–1934), a Swiss immigrant who was the company's vice president and manager. Here he is seen around 1920 with his wife, Ida (nee Rakow). (Author's collection.)

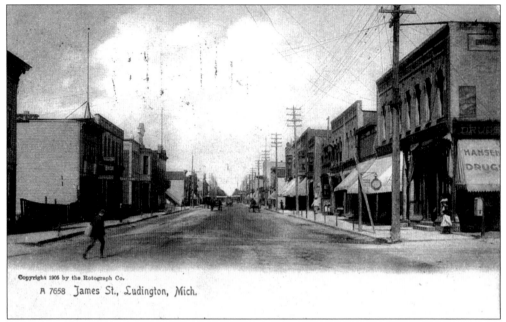

A 7658 James St., Ludington, Mich.

Here James Street is seen north from Foster Street in 1905. In the block at left, the building with the oriel window is Charles Boerner's office; the next building to the north, with the balcony, is German Hall. At far right is the building occupied in 1905 by Svoboda and Honsowetz (with men's clothing) and C. J. Hansen's Drug Store. Note the clay-improved street and the multiplicity of telephone poles. (Author's collection.)

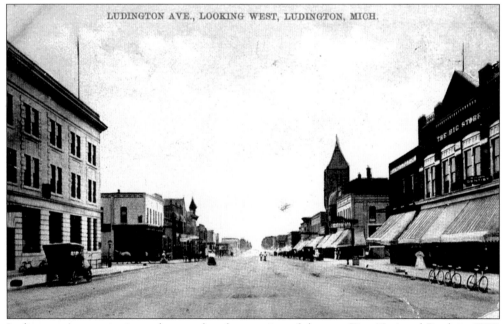

LUDINGTON AVE., LOOKING WEST, LUDINGTON, MICH.

Ludington Avenue is pictured soon after the opening of the new First National Bank in 1907. On the next corner is the Huston Building, occupied by the Ludington State Bank and H. V. Huston, hardware dealer. At the far right is the Busy Big Store, with Latimer's Drug Store on the corner. (Author's collection.)

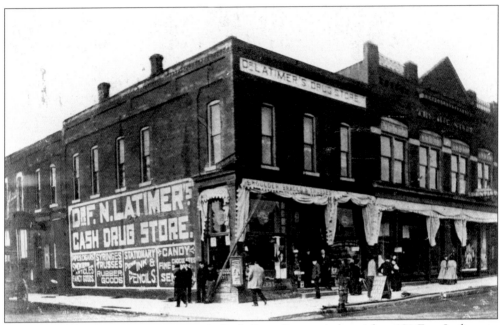

Established in 1878, Dr. F. N. Latimer's Cash Drug Store was located at 101 East Ludington Avenue from 1897 until its sale in 1912. Frank N. Latimer was the husband of Fannie Allen; Frank's brother, Harry I. Latimer, was in the hardwood business in Wisconsin with Fannie's first cousin, George E. Foster. (Author's collection.)

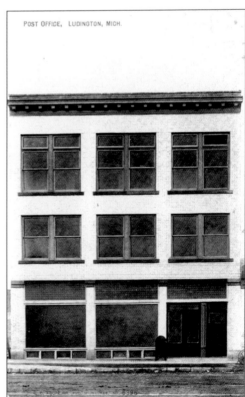

In 1909, the Post Office Block was built by Claude M. Curtiss at 112 East Ludington Avenue with the post office on the first floor, rented offices on the second, and a meeting hall and ballroom on the third. When the post office moved to its present location in 1933 this building was remodeled as a J. J. Newberry store. (Author's collection.)

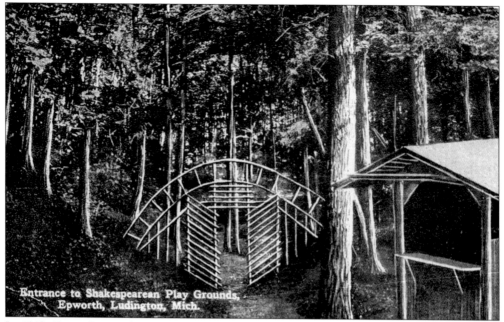

Entrance to Shakespearean Play Grounds, Epworth, Ludington, Mich.

In 1907, Epworth was the scene of a visit by Ben Greet and his company of Shakespearean players from England. (They also performed for Pres. Theodore Roosevelt on the south lawn of the White House in 1908.) An outdoor Shakespearean theater was erected at Epworth, and Greet's company performed here again in 1909, 1911, 1912, and 1915. (Author's collection, gift of the late Doris Foster Lessard.)

In 1908, Frank A. Foster married Hedwig Tiedemann (1876–1962). The eldest daughter of August Tiedemann, the architect and builder, "Hattie" was an insurance agent and deputy county treasurer previous to her marriage. Mrs. L. H. Foster thought her son had married beneath his class, but the couple were the parents of Doris Foster, who became a prominent historian, genealogist, and antiquarian. (Courtesy of the late Doris Foster Lessard.)

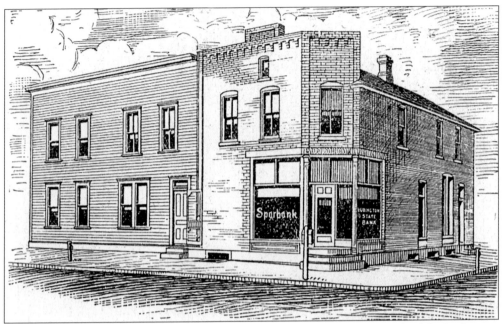

Built in 1890, this red brick building was occupied by the Fourth Ward branch of the Ludington State Bank from 1907 to 1933. Its managers were Andrew W. Newberg (until 1921) and Claude Bailey. The illustration is from the *Ludington Record-Appeal* of April 23, 1908. Note bilingual (English and Danish) window lettering, the Danish denoting "Savings Bank." Located at 1002 South Madison Street, the building has been home to Christa's Antiques since 1982. (Author's collection, gift of Christa Shoup.)

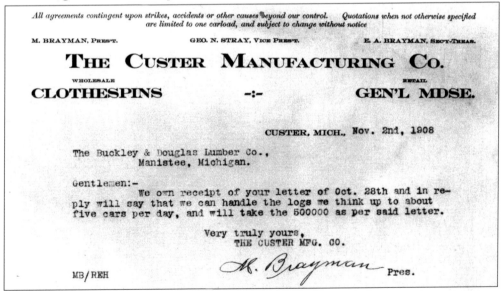

From 1884 until 1909, the Custer Manufacturing Company operated a large woodenware factory 12 miles east of Ludington. Marshall Brayman, a pioneer of 1869, was president of the company; for a number of years George N. Stray was vice president. In this letter of November 2, 1908, Brayman accepts the offer of the Buckley and Douglas Lumber Company of Manistee to sell the factory 600,000 feet of hardwood logs. (Courtesy of Jack Holzbach.)

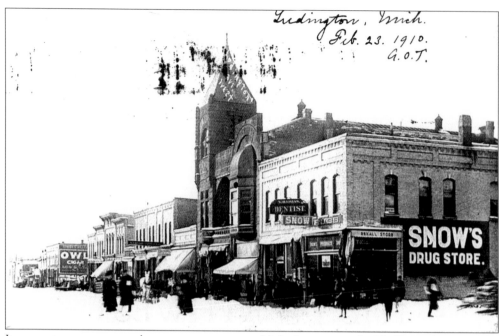

It was not uncommon to have current scenes published as postcards. "Cold weather" was the terse message of one AOT, the sender of this card in February 1910. The corner building is the White and Danaher Block, built in 1881. Note that Snow's Drug Store has an electric sign, probably the first in Ludington. The sandstone building with a large tower is the Masonic temple, built in 1888–1889. (Courtesy of Jerry Cole.)

Born near Ovid, Michigan, Virgil A. Fitch (1860–1938) was a judge in Dakota Territory before coming to Mason County from California in 1893. He moved from Scottville to Ludington in 1906. A justice of the peace and later prosecuting attorney, Fitch served in the Michigan House of Representatives for the sessions of 1919, 1925, 1926, and 1927. He is pictured here with his eldest son, Roscoe Conkling Fitch. (Author's collection.)

Eight

GATEWAY TO
THE NORTHWEST

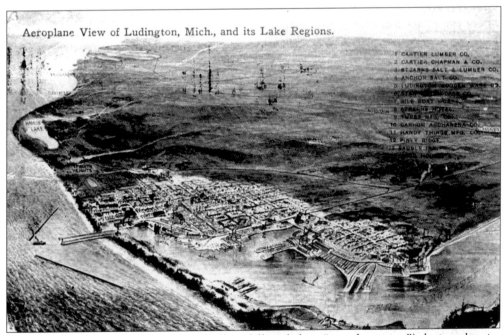

Aeroplane View of Ludington, Mich., and its Lake Regions.

1 CARTIER LUMBER CO.
2 CARTIER CHAPMAN & CO.
3 STEARNS SALT & LUMBER CO.
4 ANCHOR SALT CO.
5 LUDINGTON WOODEN WARE CO.
6 STEARNS CHICAGO CO.
 MILE BOAT WORKS
8 STEARNS HOTEL
9 TUBBS MFG. CO.
10 CARROM ARCHARENA CO.
11 HANDY THINGS MFG. CO.
12 PINEY RIDGE
13 SAUBLE INN

This artist's view of Ludington in 1910 (fancifully titled an "aeroplane view") depicts the city that William Rath and the Ludington Board of Trade proclaimed "Gateway to the Northwest." Freight tonnage passing through the port by car ferry far exceeded that originating from the two remaining sawmills, the output of which now moved primarily by rail. (Author's collection.)

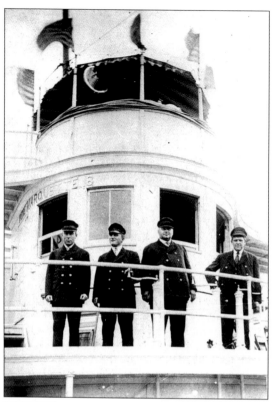

On September 9, 1910, the *Pere Marquette 18* was found to be sinking while bound from Ludington to Milwaukee. As the *Pere Marquette 17* stood by, the ferry suddenly plunged to the bottom with the loss of 28 lives; there were 33 survivors. In this image, from left to right, are wheelsman Simon Burke, Second Mate Walter Brown, Captain Peter Kilty, and First Mate Joseph Brezinski are seen on deck. Of the four, only Burke survived the disaster. (Courtesy of the late Doris Foster Lessard.)

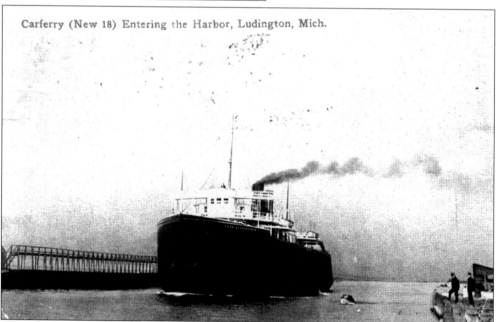

Carferry (New 18) Entering the Harbor, Ludington, Mich.

The railroad immediately ordered a new car ferry, also named *Pere Marquette 18*. Built at South Chicago, the vessel was placed in service by Captain Joseph Russell on January 30, 1911. Differing from its predecessor mainly in having fewer passenger staterooms, the second *Pere Marquette 18* was retired from service in 1952 and scrapped in 1957. (Author's collection.)

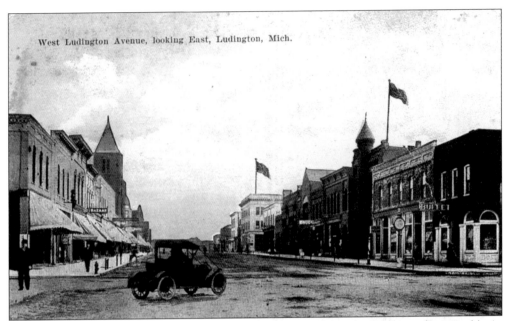

West Ludington Avenue, looking East, Ludington, Mich.

In this 1910 image, Ludington Avenue is seen looking east from Charles Street (now Rath). At far left is John D. Neumann's saloon, and at far right is Seeba's Buffet, where Diederich Seeba often played host to local businessmen. The buildings marked by flags are the new First National Bank (back), built in 1906–1907 (and where J. S. Stearns was elected president in 1910), and its predecessor (front), built in 1887–1888 and occupied by offices in 1910. (Author's collection.)

In addition to serving as superintendent of the Ludington car ferry fleet from 1899 until 1931, William L. Mercereau (1866–1957) was secretary and treasurer of the Gile Boat and Engine Company. Mercereau is seen at left with a Gile tractor in 1912. Established in 1909, the concern later became the Stearns Motor Manufacturing Company. An early casualty of the Depression, it was liquidated in July 1930. (Author's collection, gift of Jack Holzbach.)

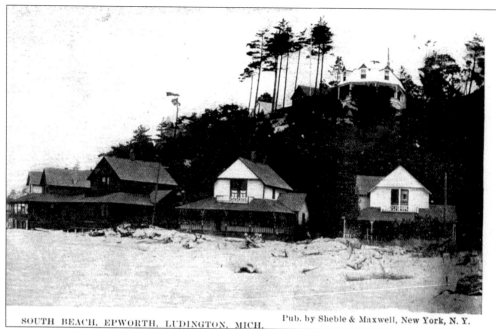

SOUTH BEACH, EPWORTH, LUDINGTON, MICH. Pub. by Sheble & Maxwell, New York, N. Y.

In this view, the white cottage with dormers on the hill is that of J. S. Stearns, named Arkansaw Inn. The leaseholders and names of the cottages on the beach in 1909 were, from left to right, J. S. Stearns Improvement Company (Umzooee), Miss Jane I. Burns (Casa Amarilla), Louis F. Ward of Detroit (Sunset Villa), Michael B. Danaher (cottage not named), and William Rath (Pine Grove). (Author's collection.)

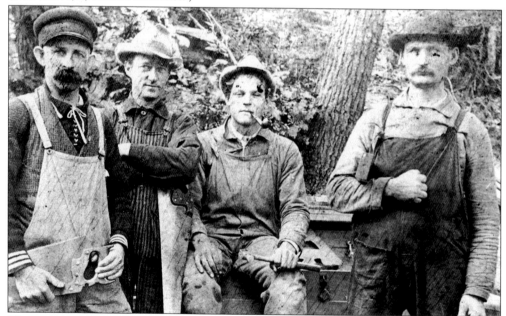

These men were among the builders who constructed cottages at Epworth and Ludington around 1910. From left to right, they are Albert Fortune, Horace Lessard, Steve Fortune, and Samuel Marburger. Horace Lessard was the father of Ray Lessard, the historian and railway executive. (Courtesy of the late Doris Foster Lessard.)

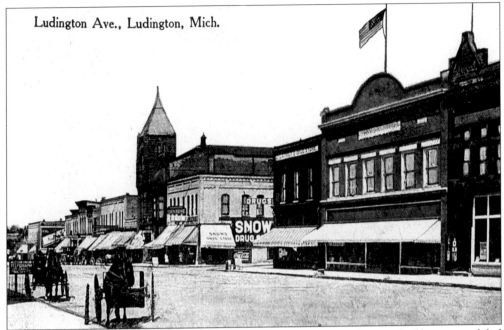

Ludington Ave., Ludington, Mich.

In this 1911 view, the building with the rounded gable is the Busy Big Store; it had been remodeled with a new façade in 1910. At far right is the McMaster Building, erected in 1890 by newspaper editor Thomas P. McMaster and occupied until 1909 by the post office and until 1914 by the offices of the *Ludington Record* and its successor, *Record-Appeal*. (Courtesy of Jerry Cole.)

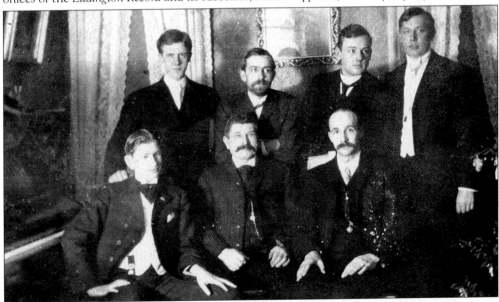

Gustav Groening (1851–1921) established his boot, shoe, and men's clothing business ("sign of the golden boot") on James Street on 1882. In this c. 1910 image, he is seen with his staff: (seated) Reinhard Groening, Gustav Groening, and Frank Washatka; (standing) unidentified, Richard H. Wilde, unidentified, and William R. Groening. Washatka was a partner from 1887 to 1913. The firm was known as Groening Brothers and Wilde from 1921 to 1926. (Courtesy of LeRoy H. Meyer.)

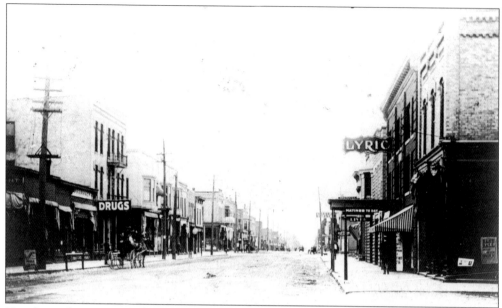

Here James Street is viewed from Loomis around 1912. The three-story building at left was built in 1887 as the Bethune House. Renamed the Road House in 1890, the hotel was converted into apartments in 1911; it burned in 1962. At right is the Lyric Theater, built in 1910 on the site of the Ludington Opera House. It was rebuilt in 1926 and renovated in 1990. (Courtesy of the late Charles Gebhardt.)

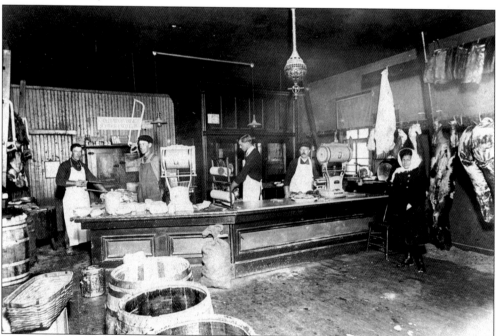

James Madsen and Peter Johnson operated a meat market at 401 South James Street in the early 1900s as Madsen and Johnson. The store is seen in February 1912 with, from left to right, Frank J. Madsen, James Madsen, unidentified, Peter Johnson, and unidentified. Frank Madsen later operated his own market. (Courtesy of Margaret Utley.)

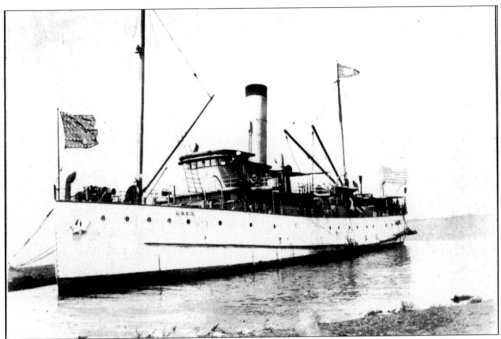

Harbor improvements have always been an important issue. Seen at Ludington in 1908, this government dredge was an annual visitor. Built in 1905 as the *General Gillespie*, it was renamed *General Meade* in 1909. More importantly, in 1906 W. L. Mercereau persuaded Congressman R. P. Bishop to sponsor legislation funding construction of an outer breakwater to create a sheltered harbor entrance. Work began in 1908 on the $1.15 million project. (Author's collection.)

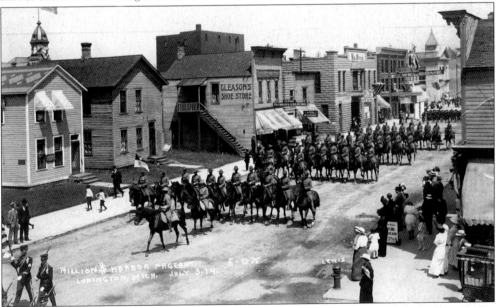

Ludington puts on a parade on July 3, 1914, to celebrate the completion of the Million Dollar Harbor. With a color guard in the lead, Troop D of the 5th U.S. Cavalry moves south on James Street, followed by a contingent of navy bluejackets and other parade units. (Author's collection, gift of June Swanson.)

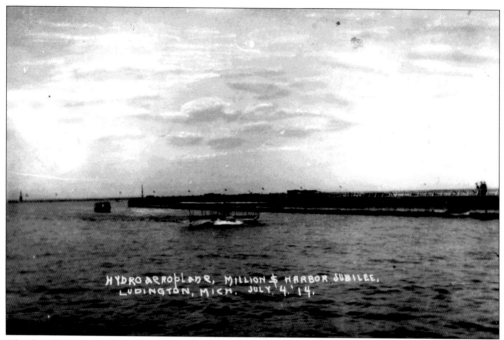

HYDRO aeroplane, MILLION $ HARBOR JUBILEE, LUDINGTON, MICH. JULY 4. '14.

The first flight at Ludington occurred July 4, 1914, when pilot Walter Johnson landed his "hydro-aeroplane" in the harbor channel during the Million Dollar Harbor Pageant. When Johnson attempted to take off again, however, the plane was unable to rise from the water despite repeated attempts. Fortunately, the spectators (including the author's grandfather, then 11 years old) were more amused than disappointed. (Courtesy of James Goulet.)

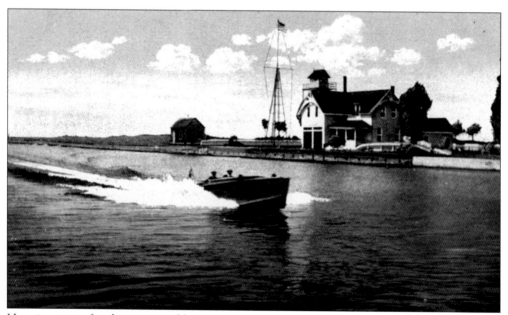

Here is a sign of a changing world: a speedboat races past the Ludington Life-Saving Station. The Life Saving Service and the Revenue Cutter Service were consolidated in 1915 to form the U.S. Coast Guard. (Author's collection, gift of the late Doris Foster Lessard.)

Nine

THE WORLD WAR

Grace Gordon is seen on Main Street (now Gaylord) in front of the home of her father, Marion E. Gordon, the real estate agent. Visible in the background at left is Buck's Storage House No. 1; at right is the original Lakeview School, built in 1885–1886 and razed in 1964. Local residents looked back on the peaceful, uncomplicated world before 1914 as a kind of golden age. (Author's collection, gift of Marilyn Johnson.)

This is an early view of the home of attorney Clay F. Olmstead (1884–1945) at 504 East Ludington Avenue. The influence of Frank Lloyd Wright's Prairie style is evident in its low, overhanging roof, angular walls and windows, and stucco interior. (Author's collection, William A. Gross photograph.)

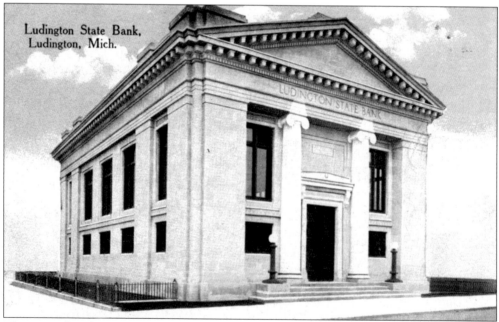

The original Ludington State Bank in the Huston Building burned May 30, 1913. After a year in temporary quarters the bank moved into its new building at 124 South James Street in June 1914. This institution became Ludington Bank and Trust in 1974, Old Kent Bank in 1986, and Fifth and Third Bank in 2001. (Author's collection.)

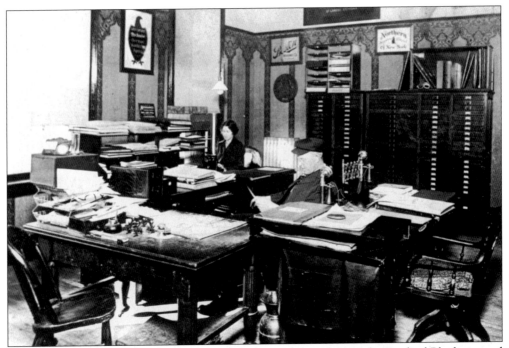

This view of Frank A. Foster in the office of his insurance agency in the Forslind Block, around 1915, is an excellent illustration of a well-appointed office of the period. Note the desk phone, file cabinet, and emblems of various insurance companies. A resident of Ludington since 1866, Foster died December 16, 1924. (Courtesy of the late Doris Foster Lessard.)

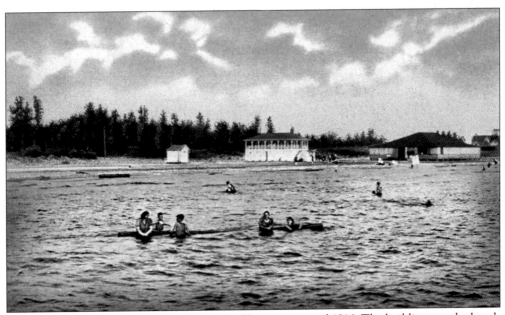

Here the Ludington Beach (today Stearns Park) is seen around 1916. The buildings on the beach are the Bathhouse, built in 1914, and the Lakefront Pavilion in its original form, built in 1915. There were then no prepared picnic sites or Park Drive. (Author's collection.)

In 1912–1913, the Ludington Country Club was built south of the Epworth golf course. Pictured is a group at the clubhouse, around 1916. It burned in November 1919 but was rebuilt in 1920. The clubhouse was converted into an Epworth cottage after the country club was absorbed in 1931 by the Lincoln Hills Golf Club, which had been established in 1919 at the former site of the National Guard encampments. (Author's collection.)

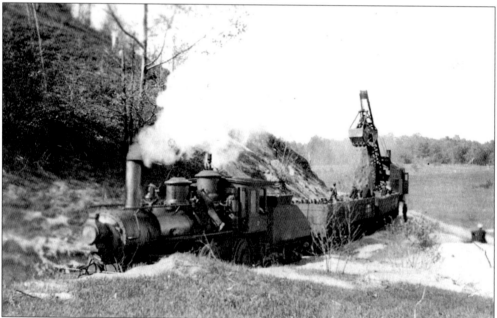

In 1916, the Hubbell Sand Company began to extract sand from a site north of Epworth, with the gondolas hauled out by the Ludington and Northern Railway using locomotives leased from the Pere Marquette. Here Pere Marquette engine No. 8 is spotted with a string of gondolas being loaded. By 1931, some 60,000 carloads had been removed and Mount Baldy was no more. (Author's collection, gift of Jerry Cole.)

The captain of the famous world's fair life-saving crew of 1893, Charles Tufts (1856–1924) was keeper of the Life-Saving Service station at Ludington from 1884 to 1897. He was sheriff of Mason County in 1903 to 1906. Tufts was elected to the Michigan House of Representatives in 1910, 1912, and 1914, and the Michigan Senate in 1916, 1918, and 1920. He is seen on Ludington Avenue in 1916. (Author's collection.)

The possibility of war was brought home in 1916 when the National Guard was sent to Texas. Regular troops under John J. Pershing entered Mexico in pursuit of Pancho Villa's marauders, but the guardsmen remained on the Texas side of the border. This remarkable view shows a Curtiss JN3 biplane of the Army flying over gunners at South San Antonio, Texas, in 1916. (Author's collection, gift of Jack Holzbach.)

Hardly had the guardsmen returned home in early 1917 than the country was confronted with Germany's declaration of unrestricted submarine warfare, the latest in a series of provocations since 1914. With American ships falling victim to German U-boats, Pres. Woodrow Wilson asked Congress for a declaration of war, which was approved April 6, 1917. Here local patriotism is expressed in the parade of July 4, 1917. (Courtesy of James Goulet.)

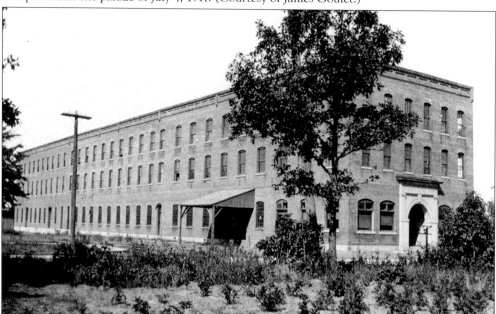

Henry L. Haskell established the Haskelite Company to manufacture three-ply birch plywood. The business was located at 801 North Rowe Street (the building erected in 1892 by the ill-fated Mendelson Manufacturing Company). *Whistling Bill*, the first plane made with this material, was a Curtiss biplane built in 1918. After the war, Haskell manufactured plywood canoes. The old Haskelite plant has been occupied in recent years by Change Parts. (Courtesy of Jerry Cole.)

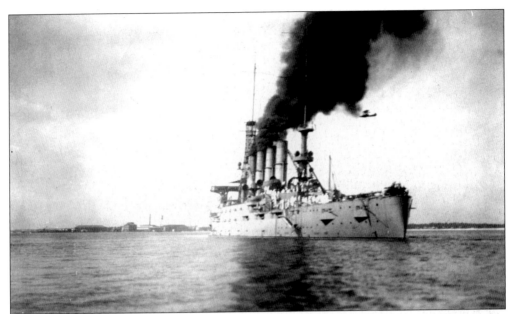

The armored cruiser USS *North Carolina* is seen with a seaplane overhead on patrol. The defeat of U-boats through the adoption of the convoy system and improved antisubmarine weapons made it possible to transport two million American troops to France. Clarence Thornfeldt of Ludington survived the sinking of the armored cruiser USS *San Diego* by a mine planted by a U-boat on July 19, 1918. (Author's collection, gift of Ed Briscoe.)

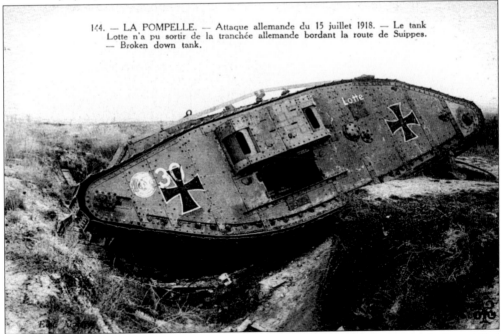

144. — LA POMPELLE. — Attaque allemande du 15 juillet 1918. — Le tank Lotte n'a pu sortir de la tranchée allemande bordant la route de Suippes. — Broken down tank.

This German tank was knocked out in the French and American counterattack that stalled the German offensive of July 1918—the second battle of the Marne. With Germany's resources exhausted, Allied offensives made rapid gains, especially after the armored breakthrough by the British at Amiens on August 8. (Author's collection.)

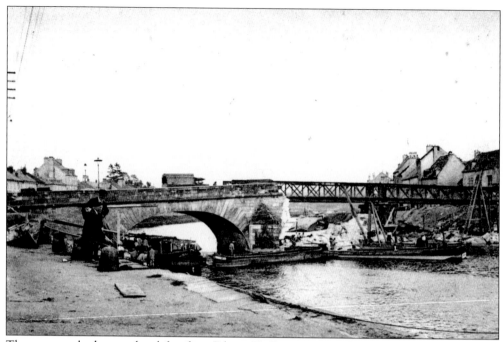

The war touched many local families. Edwin H. Ewing, namesake of Ludington's American Legion post, was wounded August 4, 1918, and died the next day. The heaviest local loss was suffered by the LeVeaux family. Emery LeVeaux died in the sinking of the tanker *Healdton* on March 21, 1917. Cosmer LeVeaux was killed by shrapnel on August 19, 1918. Their sister, Amy, an Army nurse, died in the 1918 influenza pandemic. (Author's collection.)

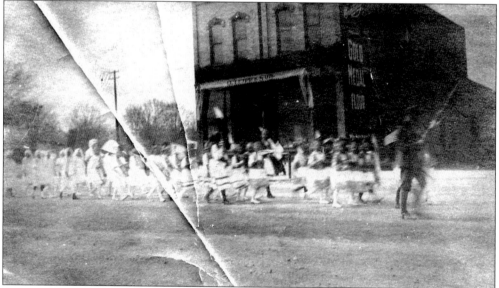

An erroneous report of the signing of an armistice on November 7, 1918, prompted the victory parade seen in this rare snapshot. The next morning, local residents were informed that the war continued. Victory was at hand, however, and Germany signed an armistice on November 11. Ludington celebrated the next day with an even bigger parade. (Author's collection, gift of Sherry Koob.)

Ten

END OF THE LUMBER ERA

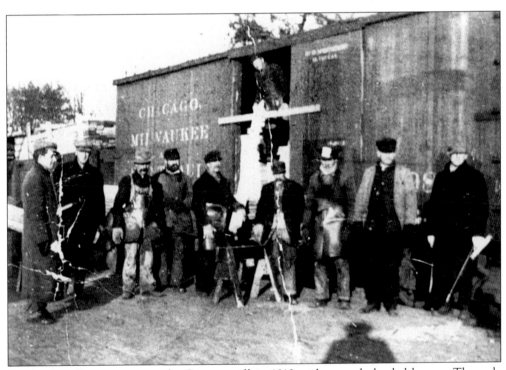

Lumber handlers are seen at the Stearns mill in 1913 with a partly loaded boxcar. The only men identified are Victor Johnson, third from left, and Lawrence Cabot (the author's great-grandfather), fourth from left. Supplied after 1906 with logs moved by rail from Kalkaska County, the Stearns mill—Ludington's last—was closed down on September 5, 1917. The salt plant was sold to Morton Salt in 1923 and dismantled. (Author's collection.)

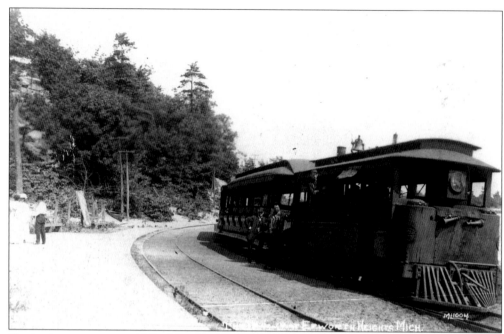

Having lost money since 1913, the end came for the Dummy in 1919. The train is seen at Epworth with conductor Kelly VonSprecken, an unidentified fireman on the ground, and engineer George Norton in the cab. The Dummy made its last run with Norton at the throttle on July 18, 1919. (Courtesy of the late Charles Gebhardt.)

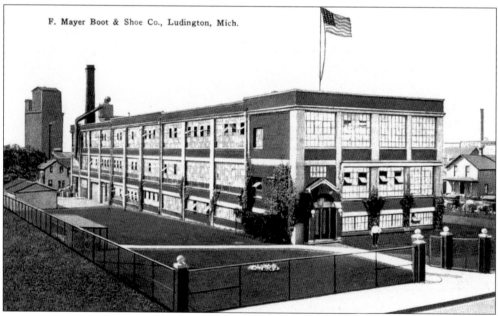

F. Mayer Boot & Shoe Co., Ludington, Mich.

In 1920, this factory was built by the F. Mayer Boot and Shoe Company at 502 South James Street with George Ebner as manager. Closed in 1927, the plant was reopened in 1934–1935 by the Weyenberg Shoe Manufacturing Company. From 1944 to 1993 the building was home to Atkinson Manufacturing (later Amerastar), a metal products concern. In March 2005, work began on renovating the building for loft condominiums. (Author's collection.)

Harmon E. Waits (1872–1951) became superintendent of schools at Ludington in 1919, serving until 1933. Under his superintendency the manual training building (later the band building, today the Ludington Area Senior Center) was built in 1922, the high school enlarged in 1925, and the school band was established by Louis F. Peterson in 1927. (Author's collection.)

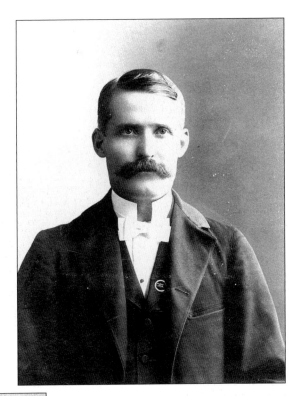

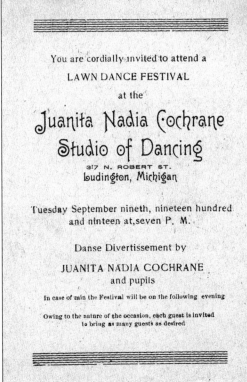

Pictured is the cover of the program for a lawn dance festival given by the Juanita Nadia Cochrane Studio of Dancing at 317 North Robert Street on September 9, 1919. Such early figures as Robert L. Stearns, Manierre Dawson, William F. Shearer, and Vera Buck in painting, Louis F. Peterson and Dagny Hansen in music, and Juanita Nadia Cochrane in dance, laid a solid foundation for the arts in Ludington. (Author's collection, gift of the late Doris Foster Lessard.)

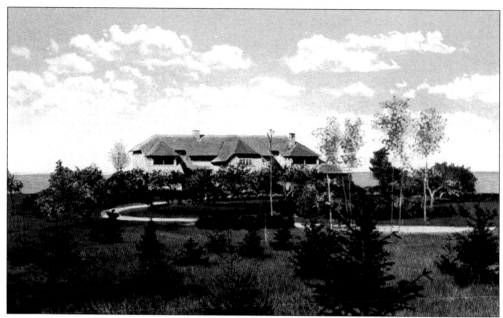

Robert L. Stearns built this summer home at Ludington in 1919, at a time when he was active in management of the Stearns Coal and Lumber Company in Stearns, Kentucky. Today the house is the Bruce Wadel home at 715 North Lake Shore Drive. (Author's collection.)

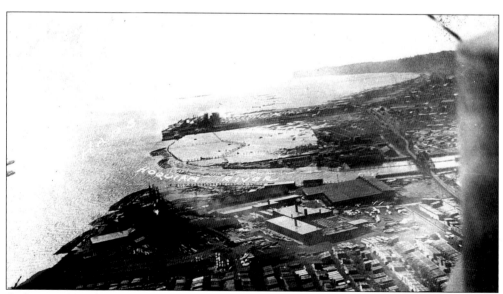

As late as 1920, the Stearns interests were expanding their lumber holdings outside Michigan. In 1920, the firm of Stearns and Culver purchased the National Lumber and Manufacturing Company at Hoquiam, Washington. This aerial view shows the mill's location on Grays Harbor, an inlet of the Pacific. (Author's collection, gift of Jack Holzbach.)

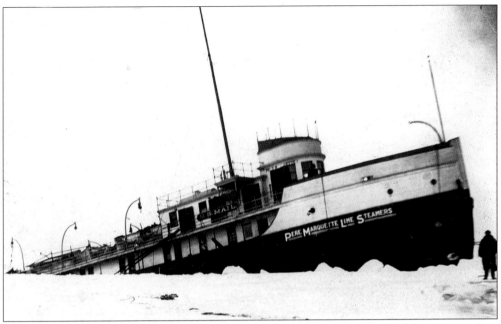

On the evening of March 7, 1920, heavy ice crushed the wooden hull of the steamer *Pere Marquette 3*, which had become entrapped off Ludington while travelling inbound from Milwaukee. All passengers and crew escaped safely. The *Pere Marquette 3* is seen slowly sinking on March 8. Much of the ship's cargo of foodstuffs was looted by townspeople who had been left impoverished by wartime rationing. (Author's collection.)

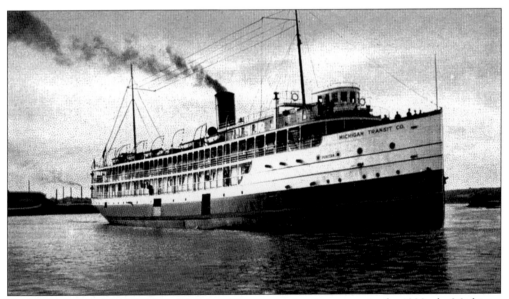

As the successor of the Northern Michigan Transportation Company, in the 1920s the Michigan Transit Company operated the steamers *Missouri* (until 1926), *Manitou*, and *Puritan*. (The *Kansas*, out of service at Manistee, burned in 1924.) The *Puritan* is seen outbound at Ludington. The line ceased operation in 1931. (Author's collection.)

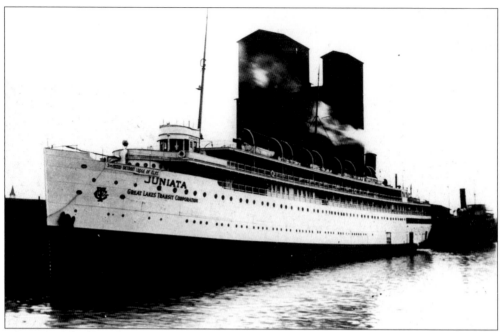

The steamer *Juniata* is seen at Ludington on June 11, 1924, with a Detroit Elka excursion. Built at Cleveland for the Anchor Line in 1905, the *Juniata* was purchased by the Great Lakes Transit Corporation in 1916. After renovation for the Wisconsin and Michigan Line, this vessel sailed between Muskegon and Milwaukee from 1941 to 1970 as the *Milwaukee Clipper*. (Courtesy of the late Ray Short.)

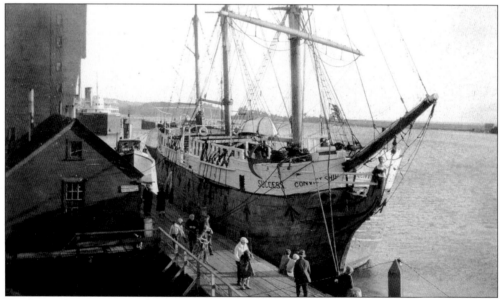

On September 2, 1924, Ludington was visited by the *Success*, a brig-rigged ship built in Burma in 1790 as a merchantman and converted into an Australian convict ship in 1802. Restored as a museum in 1890, the *Success* sailed to England and later, in 1912, to the United States. The old vessel was on the Great Lakes from 1924 until it burned near Port Clinton, Ohio, in 1946. (Author's collection, gift of the late George Egbert.)

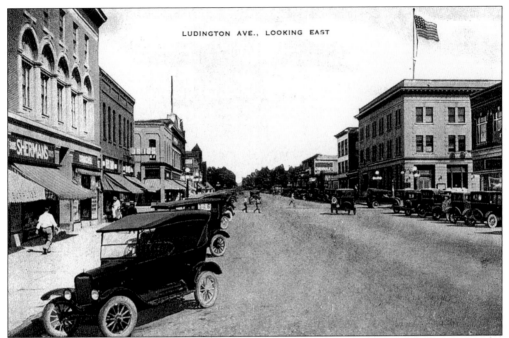

Ludington Avenue is seen looking east toward James Street in 1924 with the newly renovated Masonic temple at left. Where once there was hardly an automobile to be seen, the downtown is now thronged with automobiles. The city's first traffic light was installed at Ludington Avenue and James Street in August 1926. (Author's collection.)

Built in 1883 by the lumberman Lucius K. Baker (1855–1929), this house became the home of Robert L. Stearns in 1896 when Baker moved to Ashland, Wisconsin. Seen here in the 1920s, it was occupied by the nurses' home of Paulina Stearns Hospital from 1907 to 1967. Later occupied in turn by Community Mental Health and several substance-abuse agencies, it was demolished in February 2003. (Author's collection, gift of Jerry Cole.)

The author's grandparents, Frank Cabot (1903–1978) and Bernice Decker (1906–2000) were married on November 17, 1925. Here, they are seen with their eldest son, Frank E. Cabot, in the fall of 1926. Although now deceased, their recollections over a period of years helped to make this book possible. (Author's collection.)

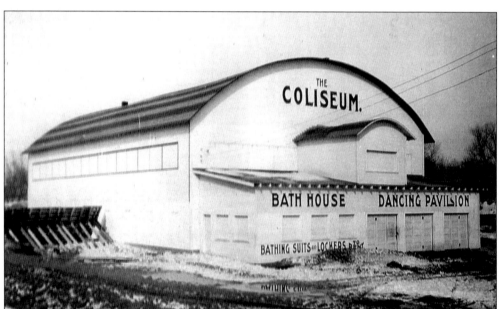

Built during World War I as the Lakefront Pavilion, the Ludington Coliseum was located at the west end of Ludington Avenue. It is seen here a few weeks before it was destroyed by fire in 1926. Rebuilt in 1927 as Rainbow Gardens, the dance pavilion burned again on December 10, 1963. The Jaycees' miniature golf course was later built at this site. (Courtesy of Jerry Cole.)

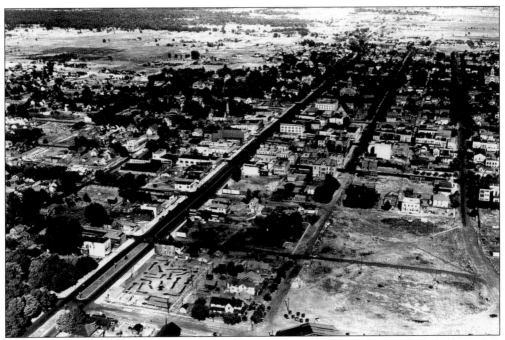

This is an aerial view of Ludington around 1930. In the foreground is Culver Park, built in 1912 as a baseball stadium. Other landmarks include city hall, the First National Bank, Hotel Stearns, the Mason County Court House, and Ludington's first, short-lived miniature golf course. The white structure on the far side of the waste ground at right is the Tiedemann Building, erected in 1911 and razed in 1948. (Author's collection, gift of Paul S. Peterson.)

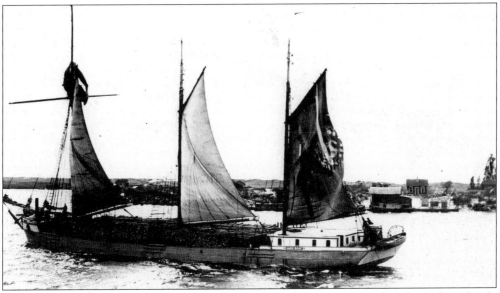

The schooner *Our Son* is seen entering Ludington harbor in the 1920s with pulpwood, evidently on account of impending bad weather—note the choppy surface of Pere Marquette Lake. *Our Son* sank in a storm on September 26, 1930. Captain Nels Palmer and the Ludington Coast Guard crew made a heroic but fruitless effort to locate the schooner, but all hands were rescued by the freighter *William Nelson*. (Courtesy of James Goulet.)

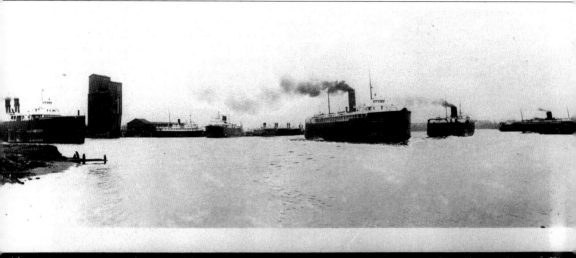

THE LARGEST CAR-FERRY FLEET IN THE WORLD IN PORT.
The PERE MARQUETTE RAILWAY COMPANY's fleet of 9 Car Ferries in
Ludington Mich. harbor at one time. Oct 29, 1930. – Ferris Photo –

In this famous photograph the nine car ferries of the Pere Marquette Railway are seen at Ludington on October 29, 1930. Five older vessels are seen with the *Pere Marquette 21* and *22*, built in 1924, and the *City of Saginaw 31* and *City of Flint 32*, built in 1929–1930. (The original *Pere Marquette* of 1897 had been renamed *Pere Marquette 15* in 1924.) Also seen is the steel package freighter *Nevada* of the Pere Marquette Line. (After the package freighters ceased service to Ludington in 1935, the grain elevator was razed in 1936–1937; the freight shed met the same fate in 1949.) This scene may be compared with the same locale in 1869 (page 13) and 1888 (page 2). Today the car ferry *Badger*, built in 1953, carries passengers and automobiles (but not railroad cars) between Ludington and Manitowoc, Wisconsin. (J. H. Ferris photograph, courtesy of James Goulet.)

Doris Foster (1913–1991) spent much of her life in the study and preservation of local history. As the daughter of Frank A. Foster and granddaughter of both Luther H. Foster and August Tiedemann, she had an exceptional interest in history, genealogy, and antiquities. Many illustrations in this book owe their preservation to her efforts. (Courtesy of the late Doris Foster Lessard.)

Doris Foster and her husband, Ray Lessard (1905–1977), a dining service manager for the car ferry fleet, did a great deal of historical work in a volunteer capacity. Here Doris models a dress that had belonged to her father's first wife, Charlotte Patterson Wood, for the 1973 Ludington Centennial. She is seen on the steps of her home, which was built in 1871 and her father purchased in 1886. (Courtesy of the late Doris Foster Lessard.)

Raymond W. Overholzer (1892–1952) began work in 1939 on a memorial to the old logging days. Building a log house near the Pere Marquette River in Lake County, he furnished it with a variety of pieces fashioned from pine wood and stumps, as seen in this 1940s view. Since Overholzer's death, the Shrine of the Pines has been maintained as a museum. (Author's collection, gift of Jack Holzbach.)

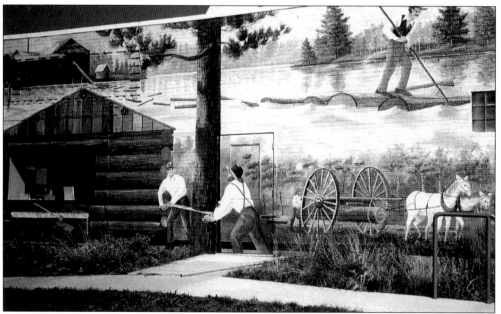

The first mural arranged by the Ludington Mural Society, *Lumbering at Ludington*, was painted in June 2003 by Terry Smith of Land o' Lakes, Florida. It is located at 305 West Ludington Avenue. The historically appropriate flowers and grasses in front of the mural were planted by Bobbie Clingan of Ludington. With its historical murals, the Ludington Mural Society is keeping faith with the city's past for future generations. (Courtesy of Ludington Mural Society.)